VERSACE

UNIVERSE OF FASHION

VERSACE

By Richard Martin

UNIVERSE / VENDOME

First published in the United States of America in 1997
by UNIVERSE PUBLISHING
A Division of Rizzoli International Publications, Inc.
300 Park Avenue South
New York, NY 10010

and THE VENDOME PRESS

Front cover photograph: Woman, photo by Herb Ritts,
coll. fall/winter 1991-1992. © Archives Versace.
Back cover photograph: Man, photo by Bruce Weber,
coll. spring/summer 1989. © Archives Gianni Versace.

ISBN 0-7893-0090-7

Printed and bound in Italy

Library of Congress Catalog Card Number: 97-060143

I n *Harper's Bazaar* of July 1977, an advertisement reads, 'Gianni Versace and Milan. Here and very now . . . A total extravagance.' The principal outfit shown is a loose silk crepe-de-chine blouse with wide pleats and a crystal-pleated collar, worn with a soft leather skirt. The look is imperial and certain, a woman with a sure sense of fashion as luxury and privilege. Versace, designing at the time for Complice and Beged-Or, was already in command of his distinctive style. Absolute power and authority are found in a visual bravado combined with comfortable materials and a relaxed silhouette. Versace was, as always, designing the most confident clothing of his time. Who else, after all, would combine silk and leather with the panache of American sportswear? Who else would have let the pleats in the silk blouse become the centre of ever-widening ripples that make troughs in the soft leather skirt? Versace sees the baroque possibilities of drapery and texture and is able to confer those characteristics on the modern woman without mitigating modern dress.

Leather is a recurrent motif in Versace's collections for men and women. He tells his 'leather story' in *Signatures*, describing how his sister, Donatella, shared leather pants and white blouses with Diana Vreeland, so that the two had not only initials in common, but also clothes. Versace reports that seeing Mrs Vreeland, in her seventies, wearing his leather pants 'led me to an even greater love for leather, which remains one of the materials I love'. It is the strength of leather and its association with sensual and raw power, as well as its colouristic and textural richness, that Versace enjoys and exploits. Though he has become internationally preeminent as the designer of unabashed sexuality, combined with a strong sense of personal grace, he remains very much an Italian designer. He is true to the materials of his culture: rippling silks in the manner of the best Pucci and the rich, irresistible leathers of Florence's glory. His gladiator boots for women of the early 1990s were not, as some imagined, a malicious misogyny – they were a means of entering Roman history and romance, of being part of the historical novel of the Roman world in which women seize real power from men.

h is men in leather – even black leather and studs – are not bikers, bar-boys or 'Village People' – they are cavaliers, paladins of vivid and epic masculinity. His metallics come out of his fanatical classicism reinforced by his abiding sense of the colourful pageantry of the Renaissance. His Autumn/Winter 1991–92 Atelier Versace woman's ensemble of full-studded motorcycle jacket worn over a studded silk crepe blouson top and pleated skirt was accompanied by large metallic belts and collars. In an era when women seek urbane armour, Versace has created a symbol of authority that is also stylish. Did Versace ask the couture workshop to make a gang or gangsta' moll or did he realize that contemporary culture already provides an imagery equivalent to Quattrocento magnificence? What Versace in fact created was a sensual contemporary woman who despite her short skirt has the powerful authority of a traditional menswear paradigm. And he created her in the template of courtly elegance.

The male counterpart to the Versace Atelier 1991–92 ensemble is the black-leather man's outfit for Spring/Summer 1993. This is not garb for The Spike or any other leather bar. The Versace man, like the Versace woman, is exquisitely sexy in clothing and prepared for a grander life's spectacle than bars. Sleeveless, with pocket escutcheons, he is destined for imagery and imagination far more enduring than one-night stands. For the scholastically *branché*, it may seem that Versace has cultivated a post-modern sensibility. He has determined that fashion's place in the world is at the centre of visual spectacle. That simplistic, almost dogmatic, credo, in which Versace firmly believes, is the reason why others may not recognize the sensibility of his work. When Versace is minimal, his reductivism is like Mondrian's, forced into the public witness. When Versace addresses sexuality, he flaunts it. When Versace appropriates art, he does so with a mad collector's rapacious eclecticism. Yet this is not hyperbole; it is fashion as the graphically enhanced spectacle of life.

Silk is another essay in material for Versace. His impeccable silk blouses, bias cut for suppleness and fullness, complement wool and leather skirts and pants. His silk skirts are fantasies of wild geometries and prints. Though he may splash silk with South Beach motifs, Pop Art graphics and other contemporary colour in the manner of film's Technicolor, Versace knows this material with all the acumen of Italian Renaissance merchants and tradespeople (not to mention Quattrocento artists). He is aware that its fundamental value is its ability to convey rich colour on a wondrously pliant field.

The Italian Renaissance is not only a paradigm of dress for Versace, but also his model for life. To say that he lives like a prince is not to say merely that he lives affluently, but that he is a modernized version of the Renaissance tradition of the learned, artistically discriminating cultural leader. Versace aspires to Medici aesthetics and authority; his synthesis is found now not only in clothing that has the distinct colours and silhouettes of Renaissance pageantry, but also in his intellectual cultivation of a neo-Platonism, and his dispersal of an aesthetic voice into every aspect of living, from clothing to home furnishings, fragrances, music and houses. Versace does not inhabit old palazzi; he makes their contemporary equivalents. His publication of sumptuous books is the indulgence of a prince. His great houses are equipped with equally great libraries. His ubiquitous Medusa is not a label in the fashion sense, but an insignia in the Renaissance tradition.

In the 1990s, like a Renaissance prince, Versace offers patronage to a Bruce Weber photography exhibition and publication which in turn became a gift to *Interview* readers and also to a Richard Avedon exhibition. He acts as co-sponsor of the 1995–96 exhibition 'Haute Couture' at The Costume Institute of The Metropolitan Museum of Art. In all these activities, he conceives of fashion not as an enterprise in apparel, but as a larger cultural energy.

What Versace shows is an unerring eye for discerning what is elegant in the continuities of contemporary life and for bringing from the street those extravagant and graceful elements that represent the best in contemporary style. No major designer living today has more successfully appropriated the street's reality and transfigured it into convincing style. Versace's friend Karl Lagerfeld sees the street sociologically and trenchantly, but Versace sees it even more distinctly and more aesthetically.

Versace perpetuates the great tradition of Italian postwar design. Recognizing that mass production and sportswear are the inevitable parameters and principles of contemporary fashion, he has continued to produce the relaxed silhouettes familiar from the work of Princess Irene Galitzine and Simonetta. Easy dressing – a demanding idea for a city like Paris, vested as it is in the formal and hand-made – is second nature to Versace. He understands that fashion operates from a principle of corporeal and visual pleasure, allowing no artifice and no restriction that is not ultimately governed by the comfort and confidence of the wearer and the spectacle of the garment in society. The new lifestyle elegance that Italy perfected in the 1950s and 1960s in combining American sportswear with Italian respect for luxurious materials is at the heart of his attainment. We could not imagine his work without the precedent of Pucci, who, with his contemporary graphic grandeur and silks, offered a flattering way for modern women to dress. A Spring/Summer 1991 jumpsuit in laminated silk tulle has the daring of Galitzine's palazzo pyjamas, but now renders the worker's coverall sheer and radiant. Versace takes the audacity even further in the corset, with unexpected military touches applied in strass embroidery. He is well aware of the combinations of luxury and utility that make clothing both practical and beautiful. He also knows those elements of the masculine that make femininity erotic and those elements of the feminine that can charge masculinity with self-conscious eroticism. The postwar Italian tradition remains operative in Versace's work; he has assimilated that past without in any way being subservient to it. His epic imagination may be stirred by

his beloved Quattrocento Renaissance, but he is also informed by the practicality and tested success of the postwar renascence in Italian design and fashion.

to the vocabulary of sportswear Versace brings the rhetorical flourish of sex. His sportswear impulse is apparent in his fascination for pants of every variety. Loose pyjama pants, tight cigarette pants, leggings and other trousers are all explored by Versace; his separates depend upon an ingenuity of matching and diversity that is one of his particular strengths as a colourist. His Spring 1997 collection for Versus (in collaboration with his sister, Donatella), for instance, mixed colours and patterns with a painter's audacity; Versace has always allowed an initial colour dissonance which soon yields to the startling beauty of the colour combinations. Colour and pattern are hallmarks of his achievement. As a colourist, he is unafraid; his patterns can be animal skins, neon-like brights or rich metals. When Versace's friend Elton John received a fashion and music award from the television music channel VH1 for his personal style, he declared his dedication to clothing that had expression and was not merely drab suits. Versace shares this feeling. Unlike more polite designers, he is always willing to risk vulgarity. The fact is, anyone who wears Versace is in danger of being over-the-top, over-the-edge, or just overdressed, but Versace knows – like any truly great artist or designer – that pleasure resides in aesthetic risk and that new fashion exists only by dint of aesthetic innovation. Not surprisingly, most of Versace's art exemplars, including Sonia Delaunay, Gustav Klimt and Andy Warhol, were notably avant-garde in their own way.

Thus, Versace's supposedly wild aspect is not a teasing lack of discrimination, but rather a determination that pushes fashion on towards the new and the adventuresome. It might be thought that a designer as

intrinsically contemplative and respectful of history as Versace is an unlikely candidate to consort with rock stars, but Versace makes it clear that he exalts contemporary culture. He never conforms to traditional fashion decorum, preferring the unabashed appreciation of the culture of his time. This gives his work an urgent, almost synaesthetic, connection that much of today's fashion lacks.

●

In fact, Versace is the only contemporary designer who fully embraces both the Madonna and Madonna. His Autumn/Winter 1991–92 collection featured the Byzantine representation of Virgin and Child. Versace did not copy frescoes or icons, but provided a more vivid contemporary version in embroidery, almost as if all the mosaics in Ravenna and Byzantium had been suddenly cleaned to their original dazzling brilliance. Art historians will never see an authentic Byzantine Virgin and Child with such arresting clarity; Versace's historicism is to render history better than it ever was. The audacity that takes him to Byzantium is typical of his forthright and recurrent use of the past. Klimt, classicism, Warhol and Pop Art, Ancient Egypt and a lascivious Art Deco Egyptomania are all evoked in the designer's encyclopaedic referencing of the art of the past, but he does not wish to replicate any of these; rather, with an innocent enthusiasm, he tries to surpass the past itself. For Versace, embroidery was a perfect medium for such a *faux* approximation and exaggeration of Byzantine madonnas.

Yet Versace also knows and employs Madonna, contemporary culture's brightest star. He effectively bridges the numinous original and the namesake. Madonna was the model for photographs of the Autumn/Winter 1995–96 collection of extraordinary plastic dresses rendered as couture. Capable as he is of conjuring up an assimilated past, Versace is equally expert in treating the life and materials of his own

time. In choosing Madonna to be photographed in couture plastic, he has brought the full energy of our media culture to the traditionally rarefied precinct of couture. Again and again, Versace, who entered couture in order to create an unqualified and extraordinary art, has made couture unapologetically contemporary. His couture lace is flirtatious; his couture silhouette is sleekly contemporary, alluding chiefly to artistic minimalism; his bias cuts are informed by tradition, but ready to party in the 1990s.

t he Autumn/Winter 1995–96 couture collection featured dresses and suits in plastic and polyvinylchloride (PVC), a concept that redefines and electrifies fashion. In an audacious act of genius, Versace brought the exacting handsewing and meticulous techniques of couture to what seem to be almost industrial-strength materials in plastic. When Elsa Schiaparelli designed in the new cellophane in the 1930s, she was trying to make use of the quintessential material of her time to advance couture. The objective was to employ an intractably modern stuff in a medium that could be either modern or traditional. Schiaparelli realized that an experiment with a lustrous new material, not customary in clothing, could only enhance the stock and status of fashion.

Not only does Versace parallel Schiaparelli's avant-garde gesture, he also specifically takes advantage of the transparency of the new medium. He has created in fashion the equivalent of the glass house, allowing the heavy see-through plastic to serve as counterpart to the structure-revealing panes of a house made of glass. Even as he sprinkles crystal and beads on the plastic, Versace creates a sparkling fantasy of a dress that seems to consist only of radiance, with no discernible core. It is a Cinderella dress of the 1990s because it shakes off all visible structure, leaving its wearer dressed only in the stars.

These 1995–96 couture dresses raise another issue as well. If the fundamental material of the dress is transparent, how can it function as any garment other than the Emperor's new clothes? Versace is deliberating on the recent history of transparency in dress, especially the plastics of the 1960s. Designers such as Rudi Gernreich, prompted by a utopian view of clothing, employed clear plastic in strategic but limited ways. Yet the wide bands of transparency used by Gernreich as part of the attention-grabbing dynamics of modesty versus clothing have become for Versace something far more subtle and unobtrusive. For the 1960s, after all, plastic was an unrefined material chiefly used in ready-to-wear.

the 1995 dress by Versace is not merely an ingenious, technology-seizing use of plastic or other new materials, in the manner of Paco Rabanne, the creative utilizer of unexpected and technologically advanced substances. It is a veritable 'Crystal Palace', akin to Joseph Paxton's clear glass building that determined modern architecture from its creation in 1851. Versace demonstrates that he can create majestic shape, like a billowing Victorian crinoline, using the wholly visible forms of transparent plastic. He treats industrial plastic as if it were couture's most supple fabric. The handsewing of this tough material is even more challenging than the demands usually asked of the couture. In a floor-length sheath of utmost minimalism, Versace employs a plastic contour and side seam with the deliberation of an artist delineating through outline, yet he has reversed the delineating element from a black-line presence to the transparent absence. Versace is familiar with Pop Art and its facility with the black line of cartoons and vernacular image, but he has deliberately made his own task the more difficult one of inferring perimeter line from its absence. Can one make a simpler, barer, clearer exhibition of an aesthetic that allows only the ornament of function? But even this abstract thinking is necessarily complemented in

such an instance by the thought that the see-through track of the garment obviates any traditional undergarment. It is revealed that no interior structure can reinforce – in, let us say, the manner of a Dior dress – what we perceive as the outer structure. Versace uses the plastic line to prove that this is a one-layered garment.

The denim-inspired dress in the collection features a martingale back that splays into a ballgown fullness at the rear of the skirt. Yet Versace's *tour de force* is that there is no superfluity of material at the horizontal line of the martingale: its transparency reveals only that the designer moves with the subtle graduation of a Grès silk from a body-hugging minimal dressmaking to the fluidity of the wide skirt. Moreover, the transparency of the materials exposes the process of sewing, a process that is paradoxically given increased importance because of its visibility. Versace has chosen to embellish the pure structure with additional curvilinear pattern.

t he same effect is found in the synergy between the consummate craft of handsewn finishing and the kind of visible machine stitching used in jeans. Arcs and curves of blue double-stitching, along with jeans-like pockets that have been transferred from back to front, provide us with an energetic mix of blue jeans and Balenciaga, suggesting on the one hand a rococo sense of ornament and on the other the colour-contrast stitching of denims. The denim reference is reinforced by the blue colour of the stitching, which leaves deliberately ambiguous the question as to whether we are looking at blue jeans or the blueprint for the glass house.

Like the appropriation of prosaic black wool jersey – the stuff of servants' uniforms – to the purposeful poetry of Chanel's little black dress of the 1920s, Versace's gesture turns on the intimacy we have with jeans and our timidity in the 1990s with respect to couture. In invoking

jeans, Versace offers couture to a new prospective client. Like his Autumn 1996 collection, with its insistent modernism and references to Cubism and abstract art, Versace is at odds with those who see couture as an art of tradition. In this regard, he is on the other side from couture designers whose consistent aesthetic is one of historicism, setting couture into the past, often the distant past. On the contrary, what Versace does in this plastic dress and in his Autumn/Winter 1996 couture collection is to place couture in the thrall of the progressive and advanced. Admittedly, there is risk in this, but Versace is a shameless exponent of the new and adventurous.

Surely we know that in our culture jeans are familiar to every couture client, even if couture is not familiar to every jeans-wearer. If we would argue in fashion history for the harmony between a cultural configuration and the character of clothing, between apparel and Zeitgeist, our current society would suggest that jeans and couture might mingle and, in fact, must coexist and cooperate. To the aphorism that 'people who live in glass houses shouldn't throw stones', Versace adds that in our culture they can't ignore Rolling Stones either.

traditionally, and even in most instances in our times, fashion designers begin with innovations in their first collections, develop fans and followers (as clients), and ultimately settle into a style that is the designer's trademark, with modest seasonal calibration, adjusting to fashion currents. Amy Spindler (*New York Times*, 8 March 1996) remarked of a Versace presentation in Milan, 'Gianni Versace ended the day with his collection, dedicated to "a woman who listens to classical music but enjoys rock, who reads *The New Yorker* and Calvino but can have a laugh at gossipy chronicles, who adores wearing Versace with Calvin Klein jeans or Versace jeans with a Chanel jacket." If that sounds like a personal ad from the back of

The New York Review of Books, it could be because Mr. Versace is not setting up housekeeping with clients who have married him in the past; he is always courting someone new.' Spindler rightly understands that Versace is always hunting for the new client, but not by obsequious ingratiation. Rather, he is a most uncompromising designer, but one who develops and expands in the public arena of the fashion runway show and in the even larger arena of popular contemporary culture, always finding new fascinations in the world around him. Versace's energy is famous; he makes it clear both as a designer and as a human being that he prizes life. Versace has been as unexpected as an actor trying out new roles, sometimes Shakespeare, sometimes opera, sometimes movies; sometimes even blue movies.

One of Versace's leitmotifs is sex. His slipdresses cling more with less material than almost anyone else's. His plunging décolletages have always nosedived toward the navel. His tight dresses and tailoring have slowed at every female curve. His lace inserts and bare apertures – learned in large part from Grès, Vionnet and other designers of the 1930s – inject not merely body's presence, but body's titillation. In menswear, Versace's erotics are equally evident. Spindler (*New York Times*, 2 July 1996) states the obvious in commenting, 'Of course, Mr. Versace has always made his men's wear message a deeply erotic one ...' Arguably, eros is a fundamental impulse in dress as both self-expression and socialization and Versace is one of the most honest designers in letting clothing serve as an overt aphrodisiac. Likewise, licence and a touch of licentiousness inhabit his favoured photographs. Richard Avedon, Herb Ritts, Bruce Weber and other photographers have created images that complement the inherent sensuality and sexual charge of Versace's clothing. Most importantly, Versace is never coy about the intrinsic sexuality in his

design or in his life. His own lusty appreciation for sexuality as a part of life differentiates him from demure, timid designers who would like to unleash the power of bodies, but cannot. Versace is a liberator for contemporary sexuality and sensuality. From the same root he is affiliated with music and media, twins of the contemporary libido and physical animation. He understands and acknowledges fashion's mediaphilic role in our culture.

Versace has said of himself, 'I don't care for half-measures. I believe in making clear-cut choices.' Versace's fashion is about such bold and unequivocal choices. Unafraid of being denounced by the insufferably polite and fearful, he makes deliberate and wilful fashion to be worn only by those who share with the designer a desire for risk, an honesty about sexuality and sensuality, and a self-confidence in aesthetic choice. Gianni Versace is brave of heart in a timid time. He is true to resplendent, bold, eye-scorching, body-arousing beauty in an indifferent and ugly era.

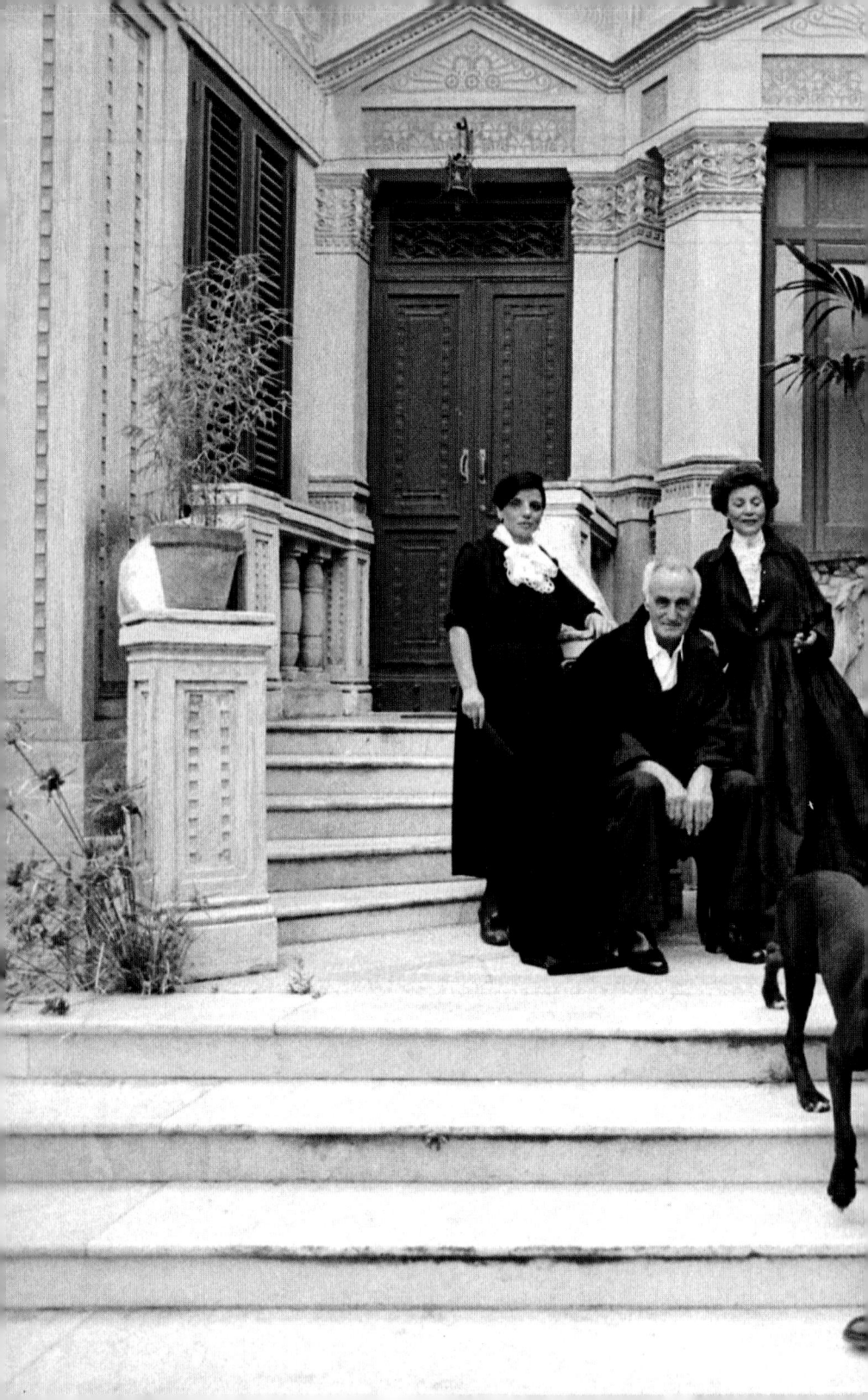

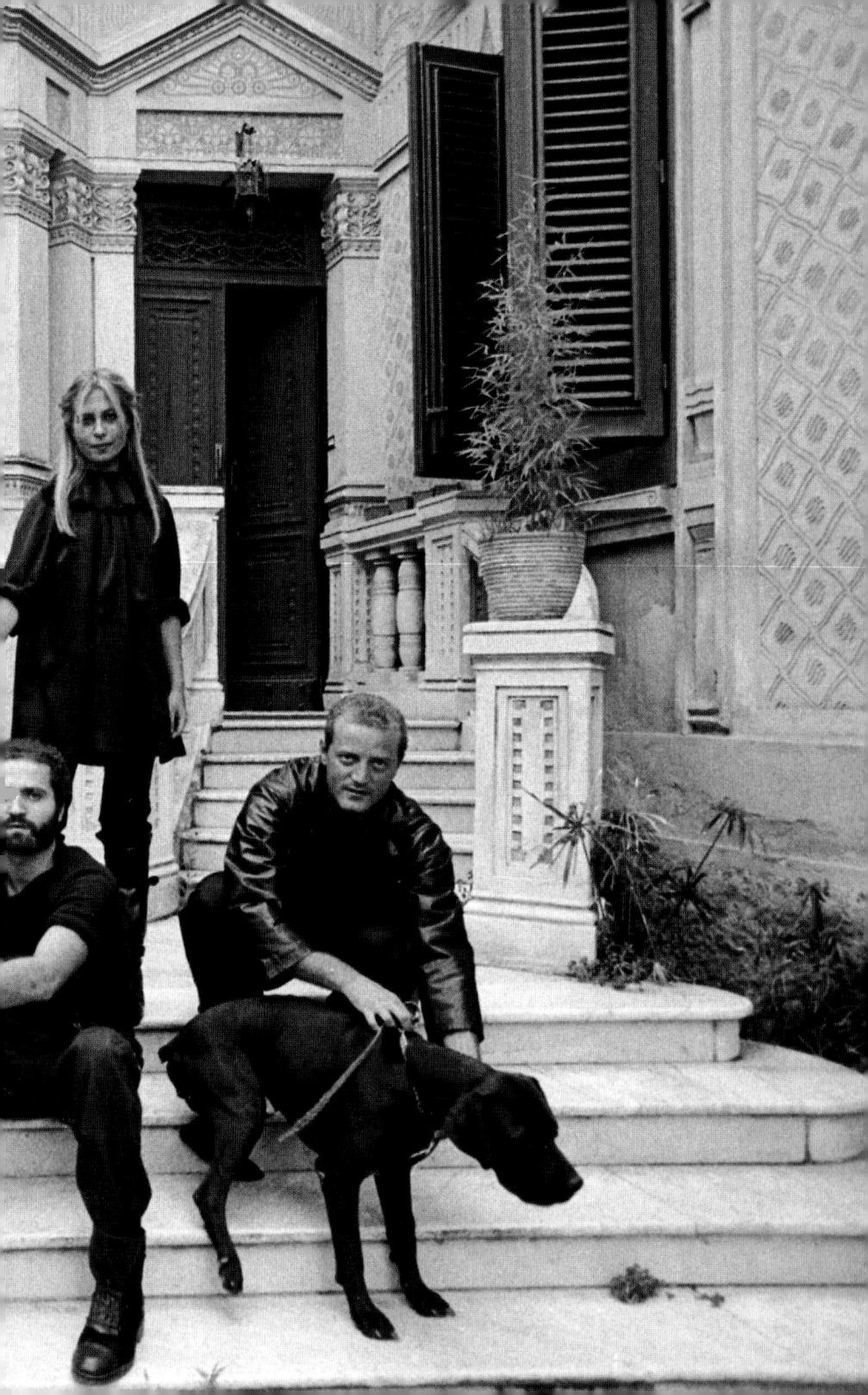

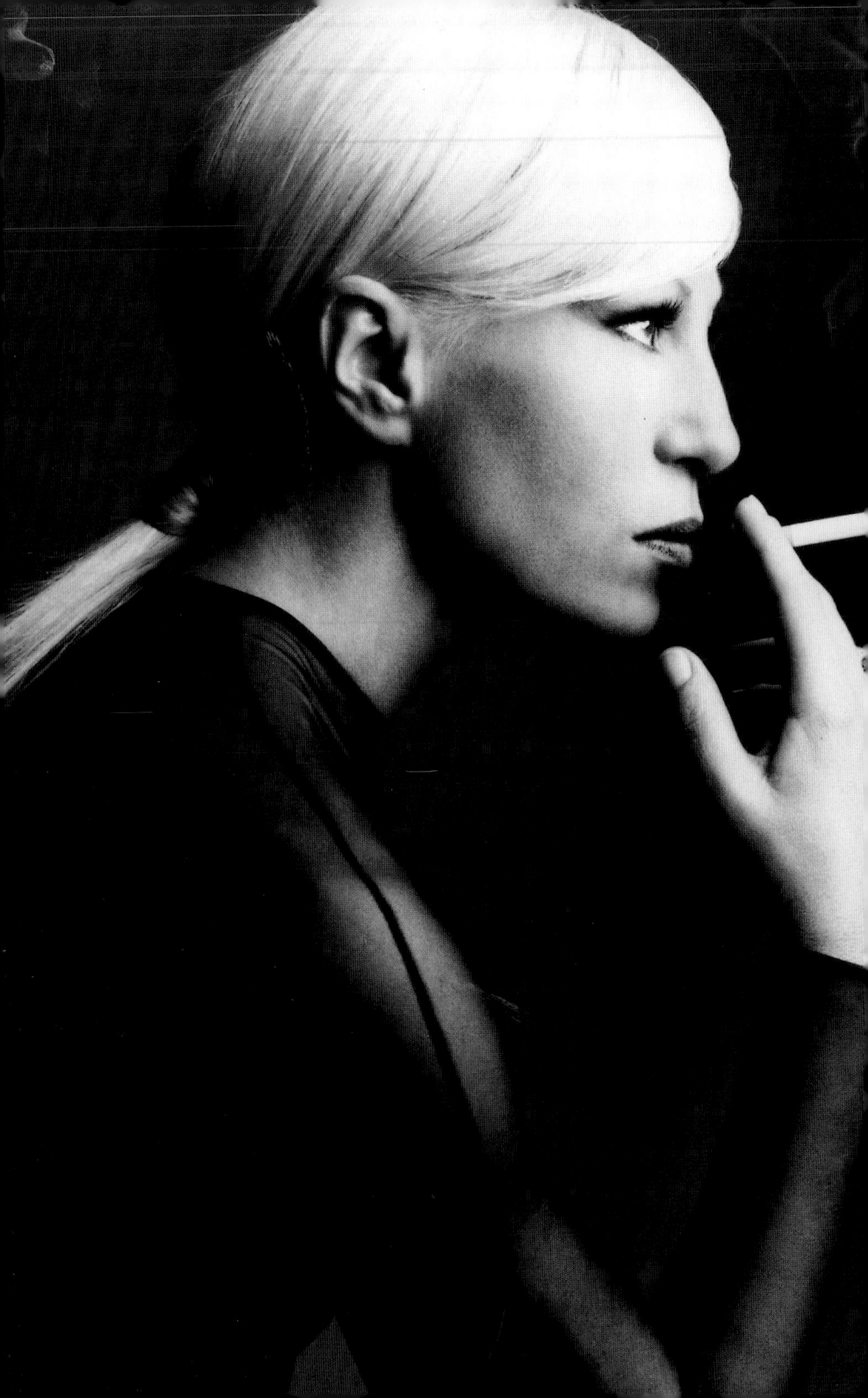

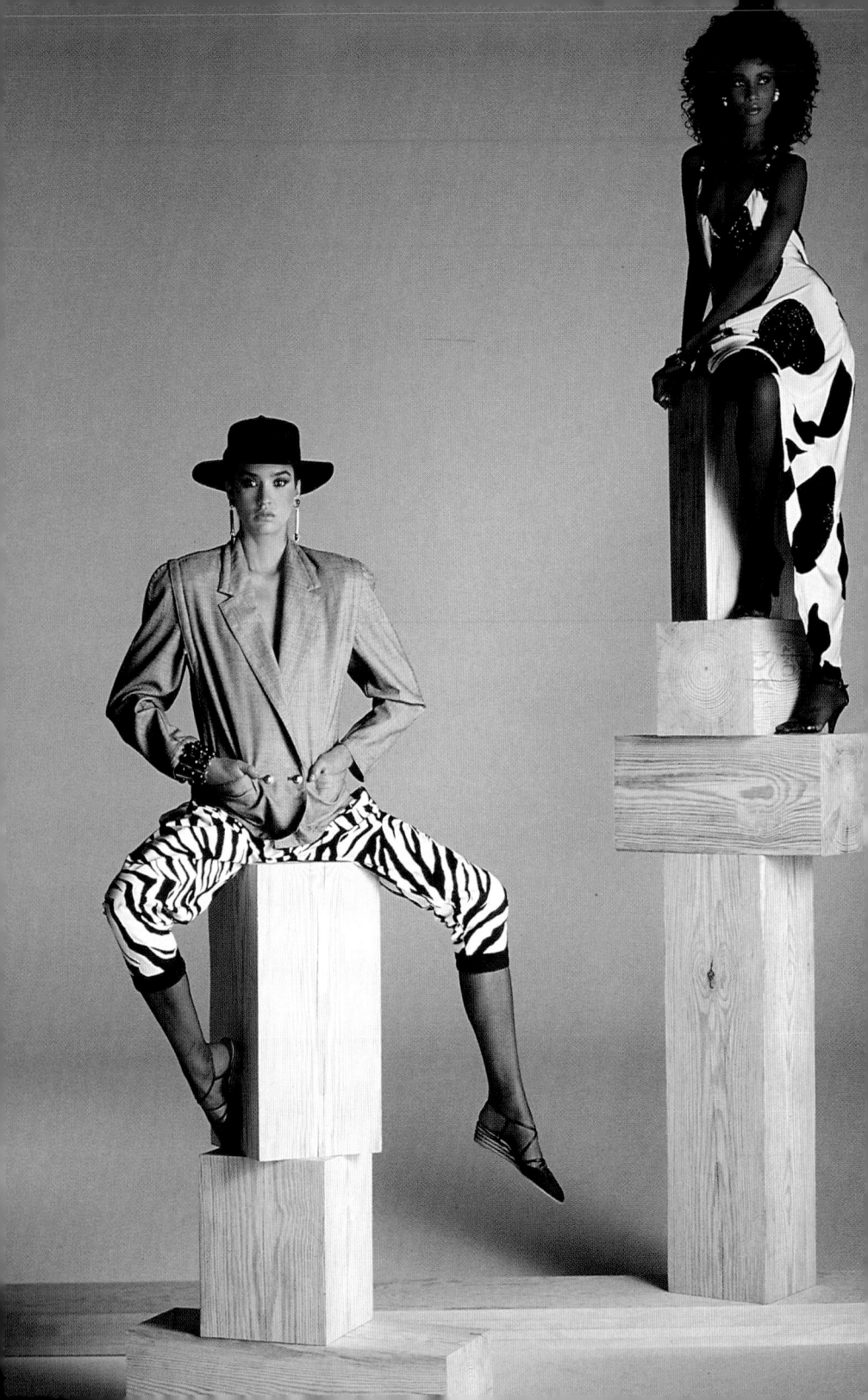

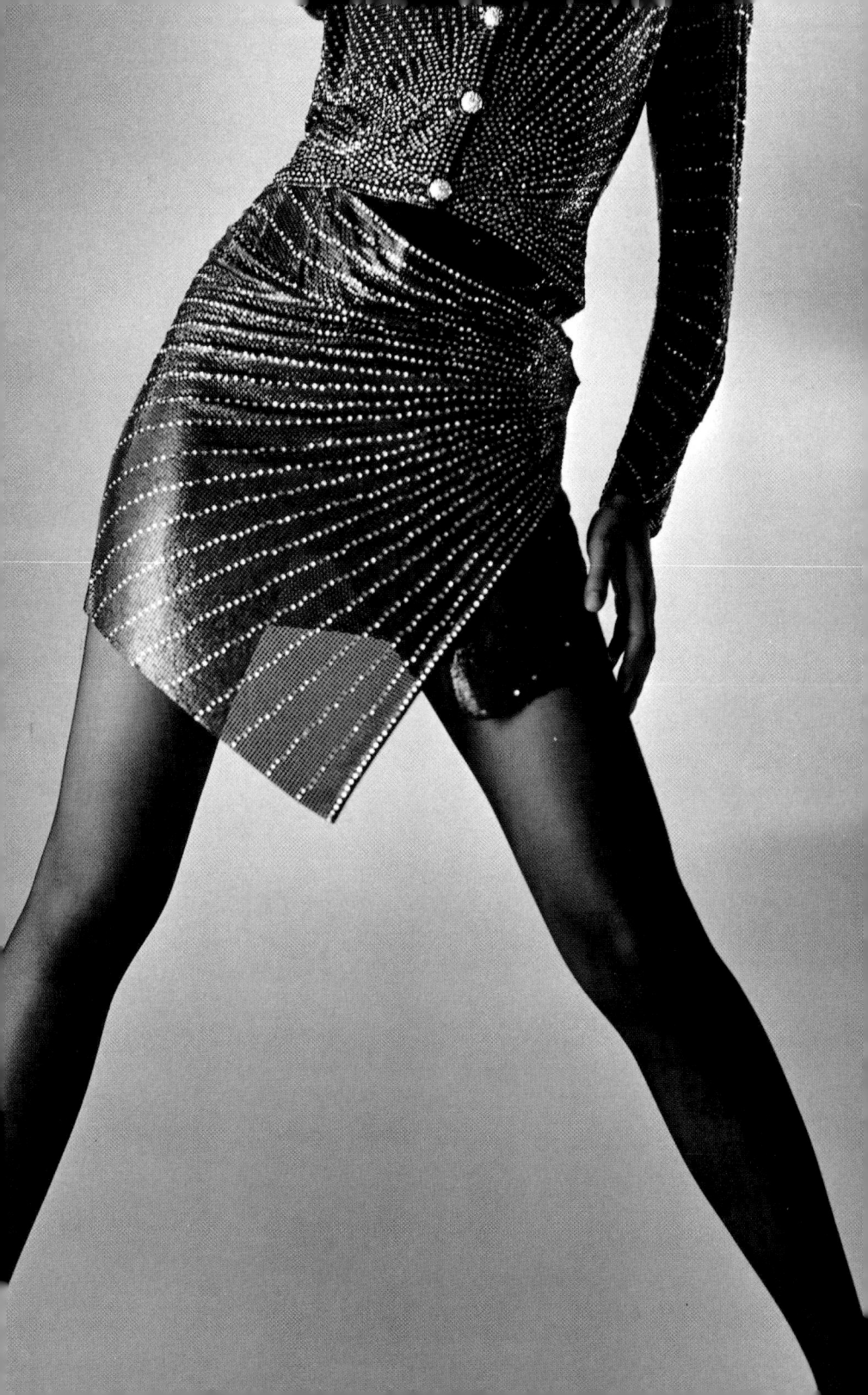

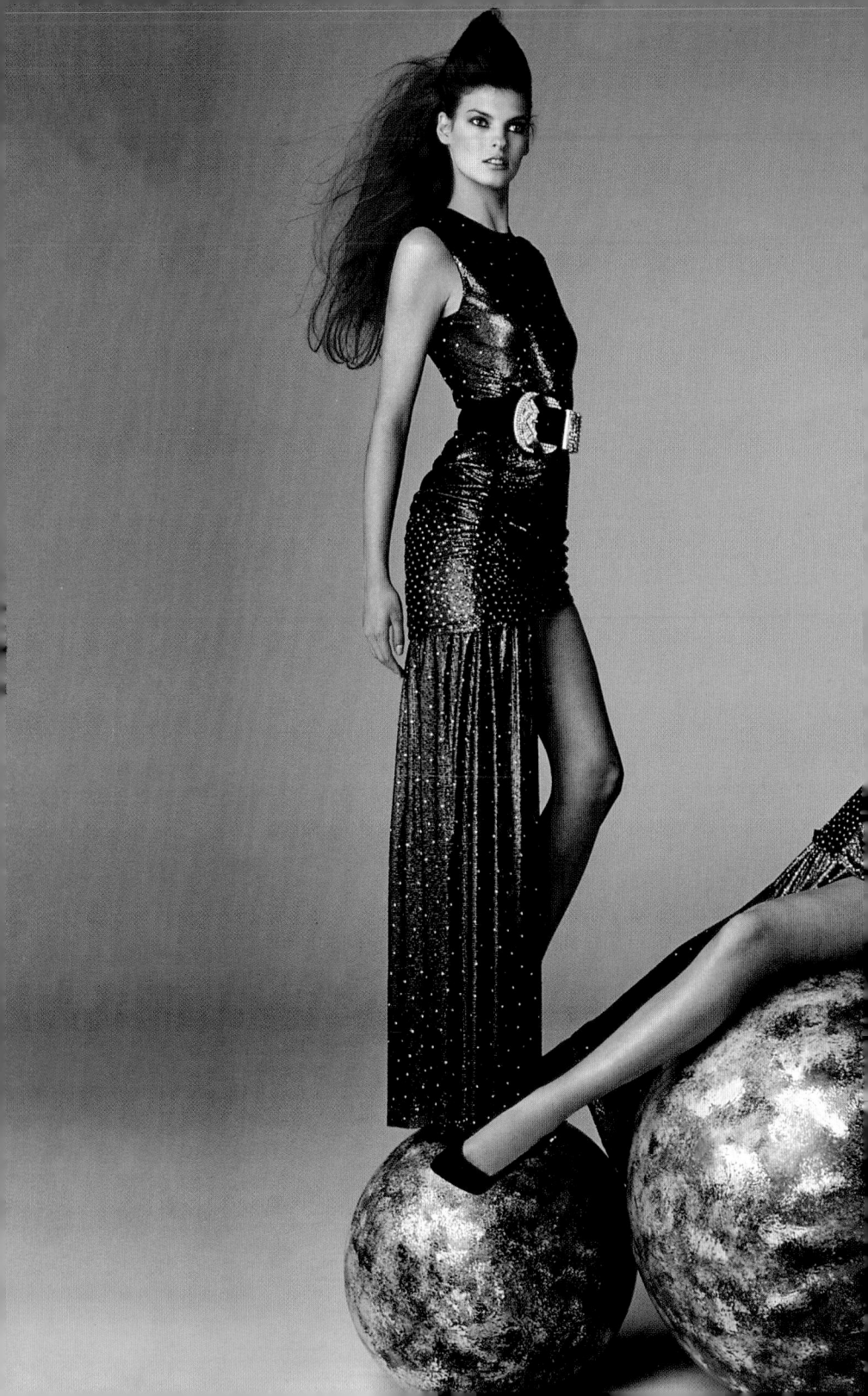

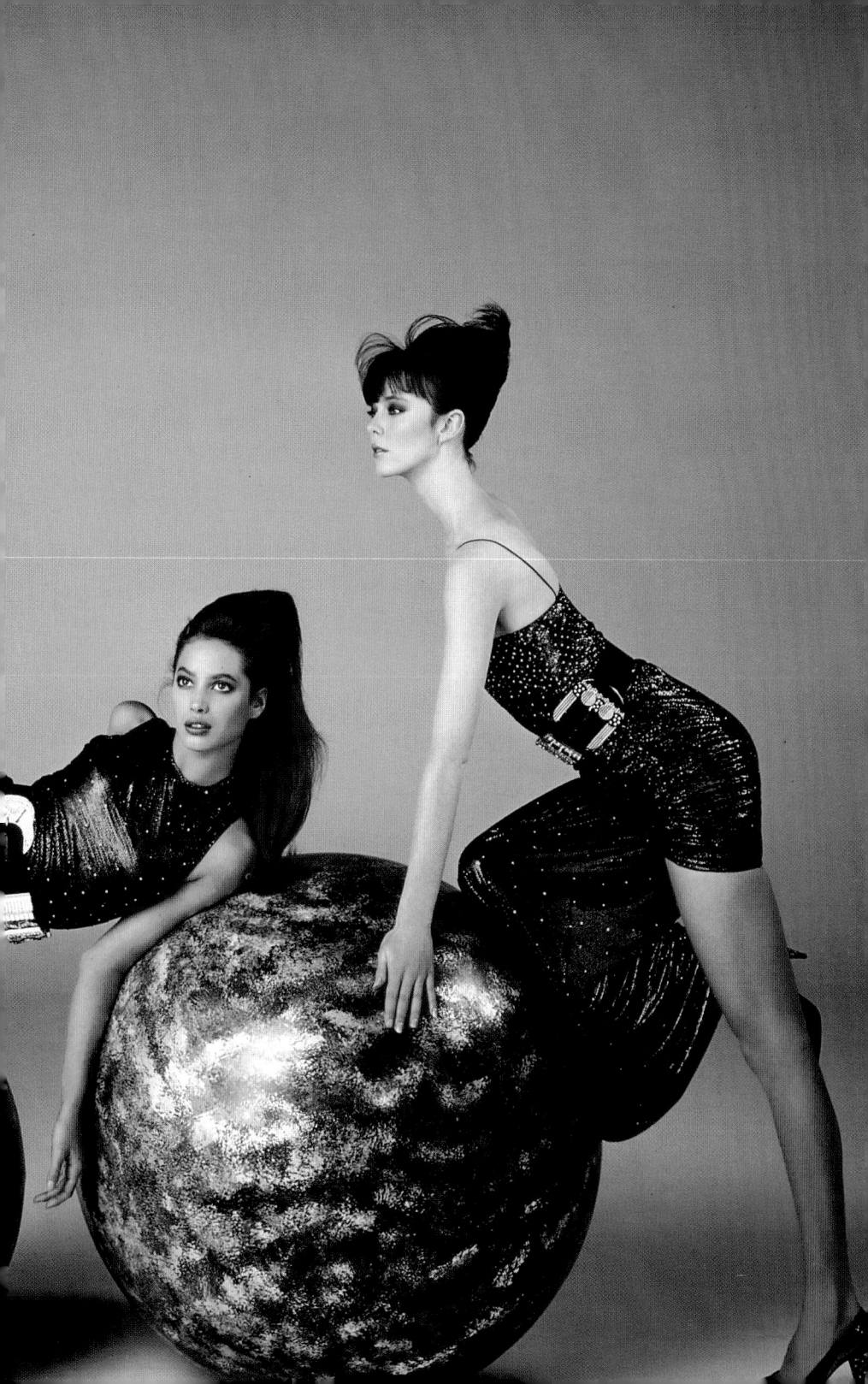

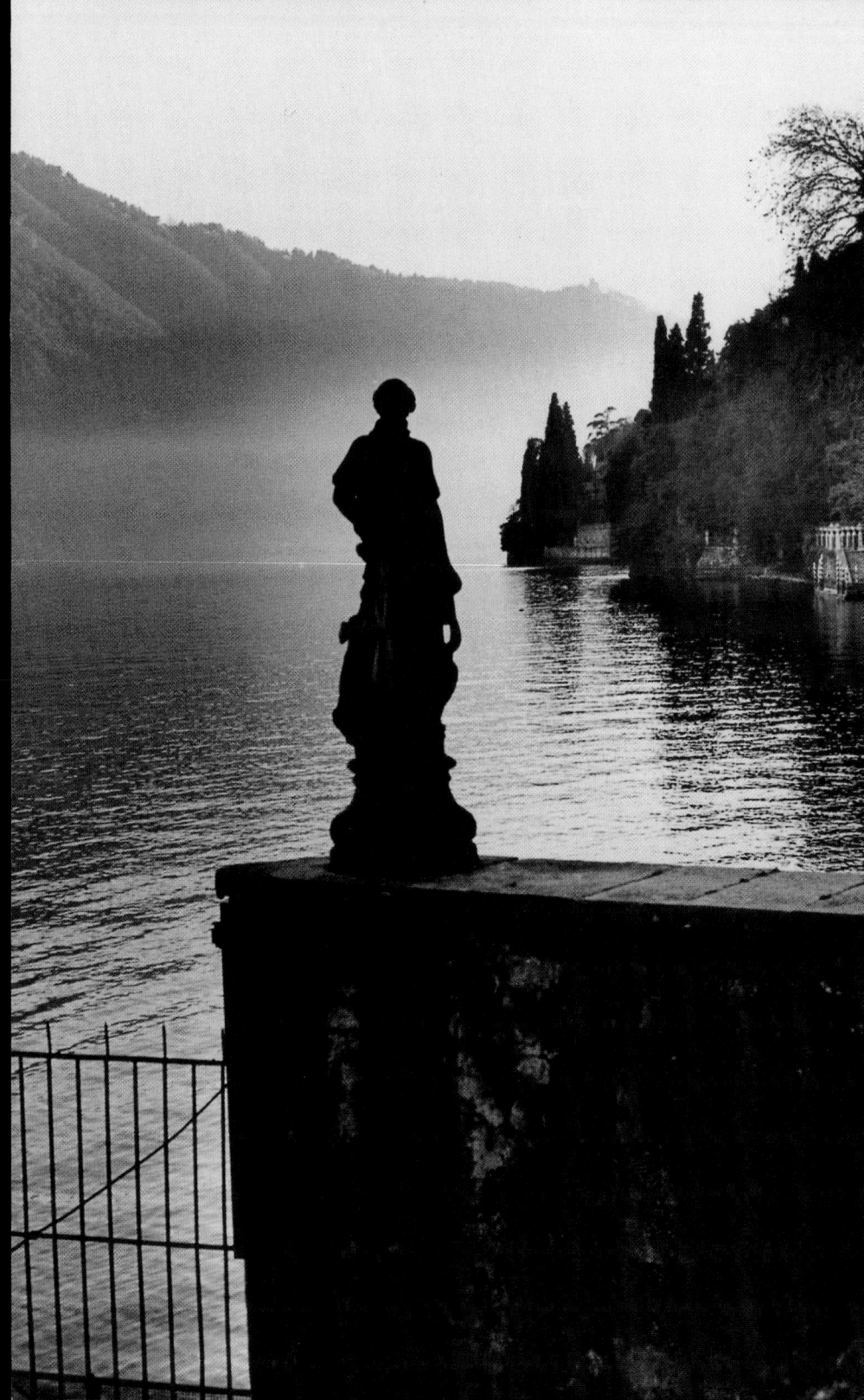

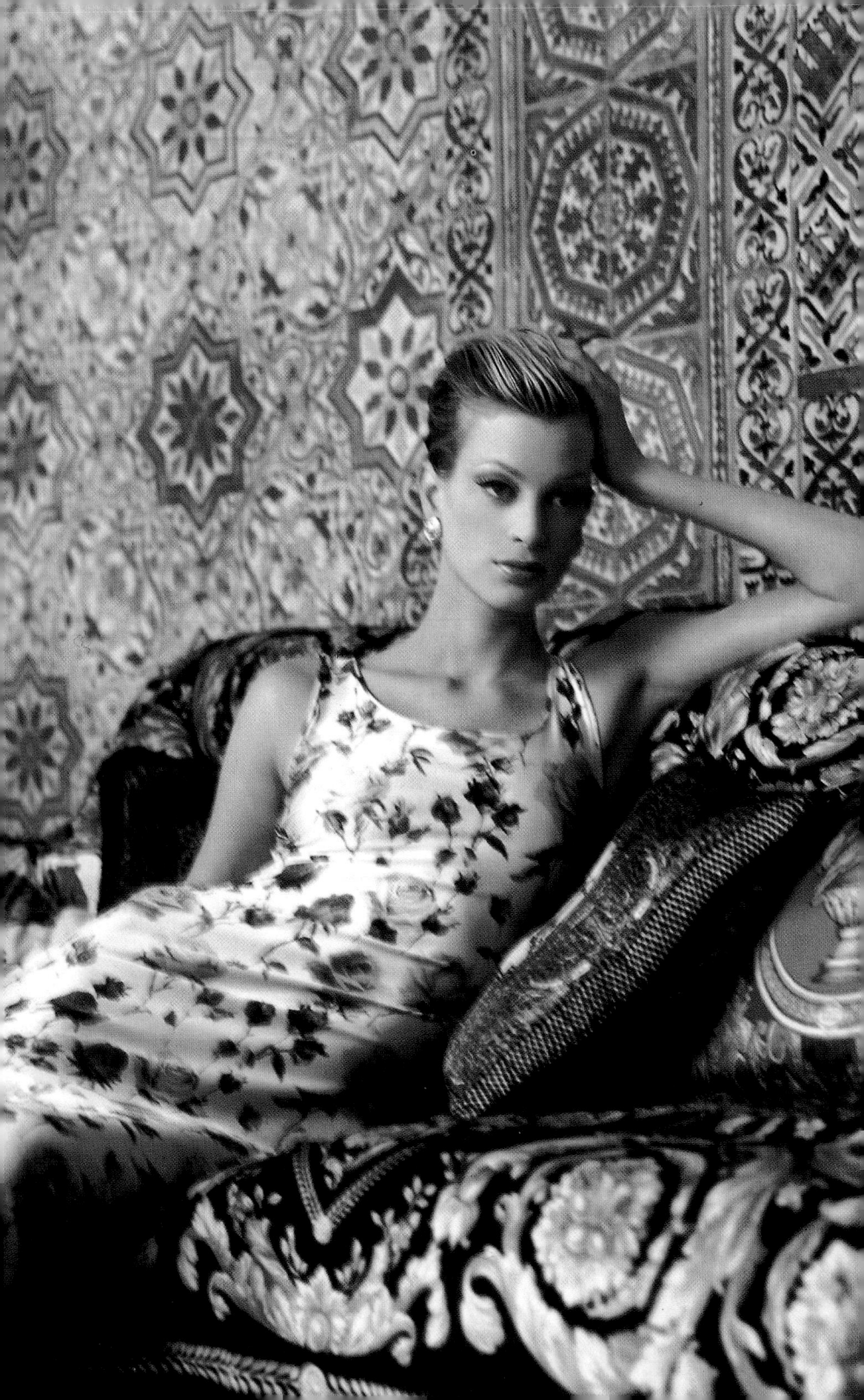

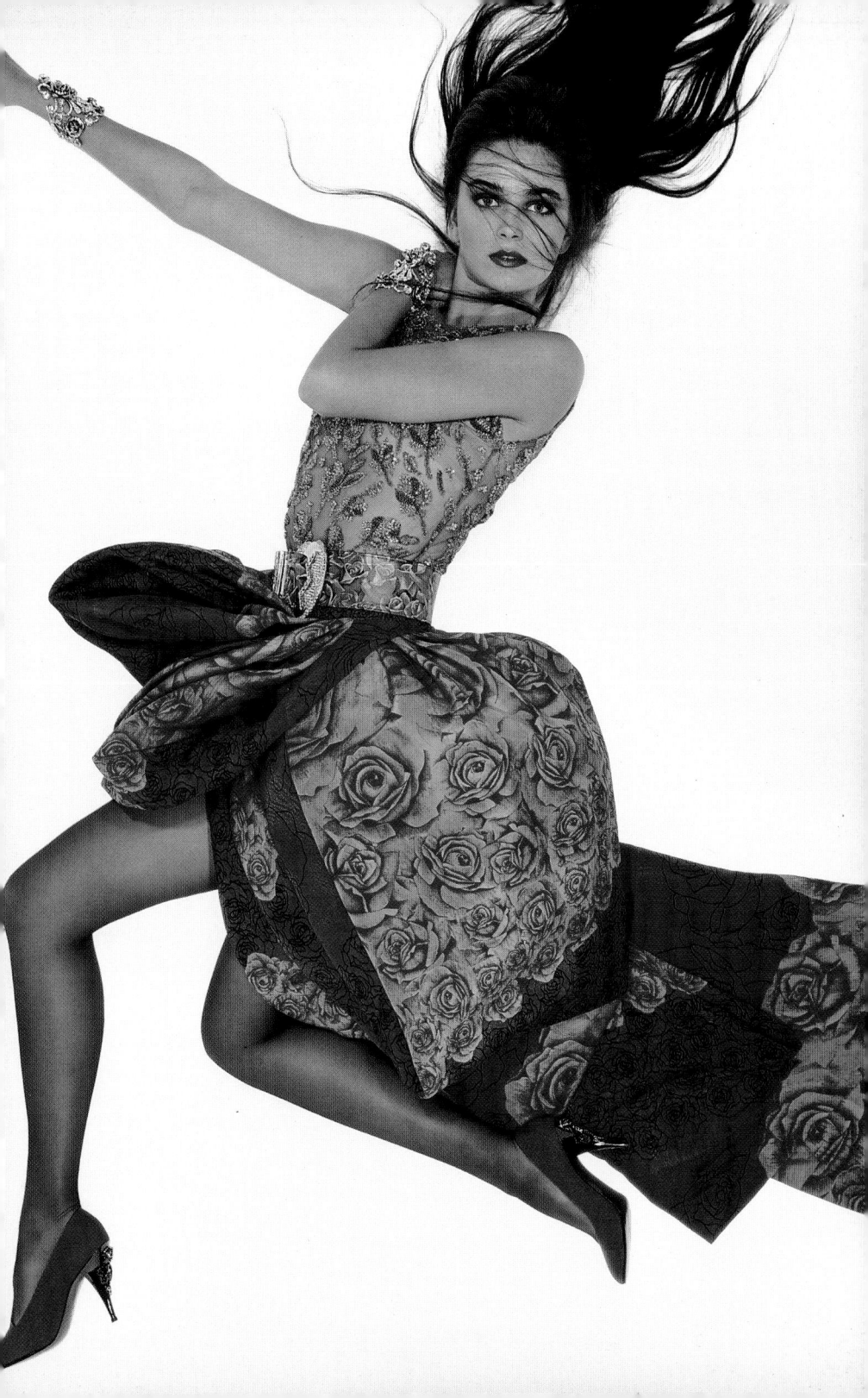

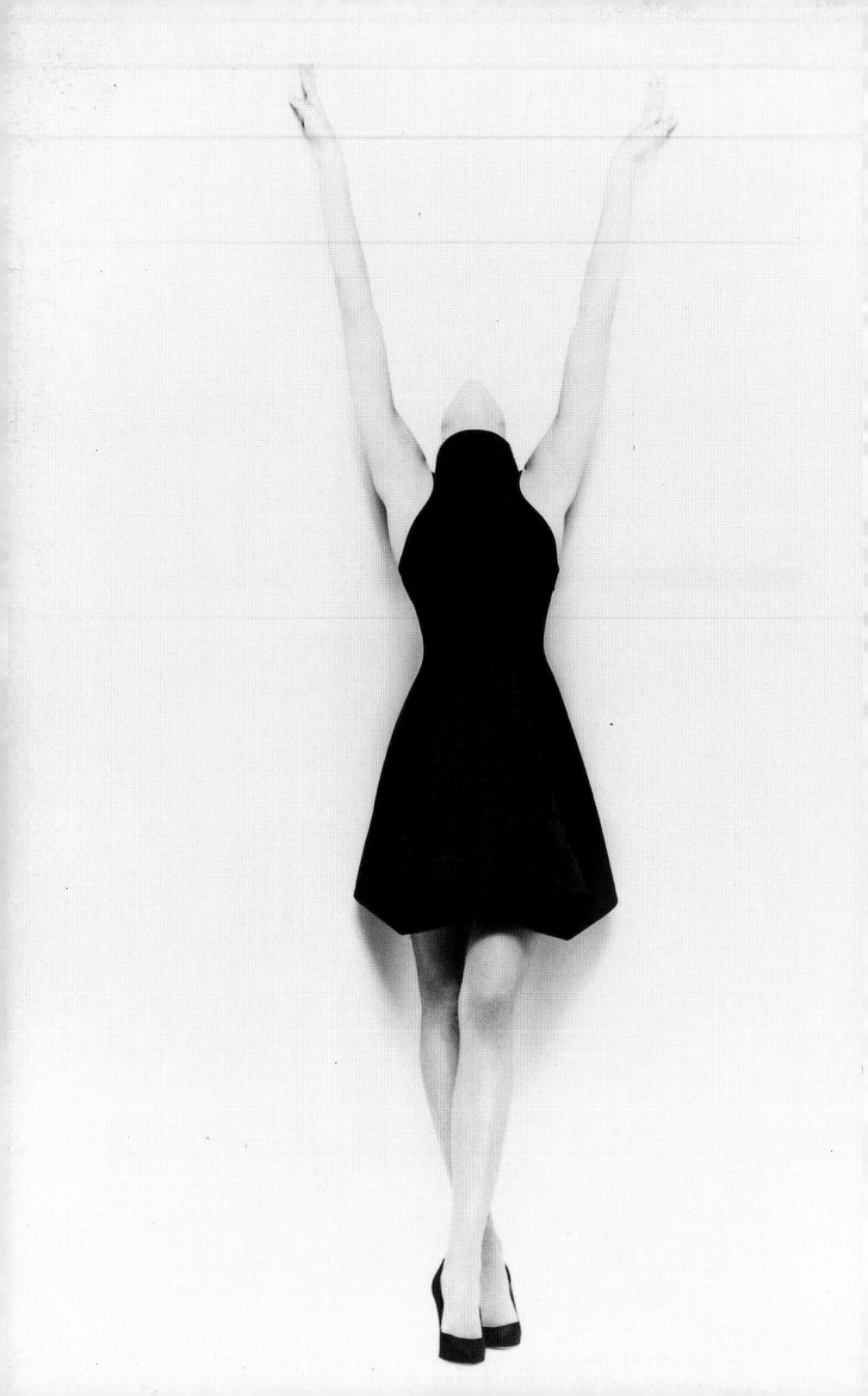

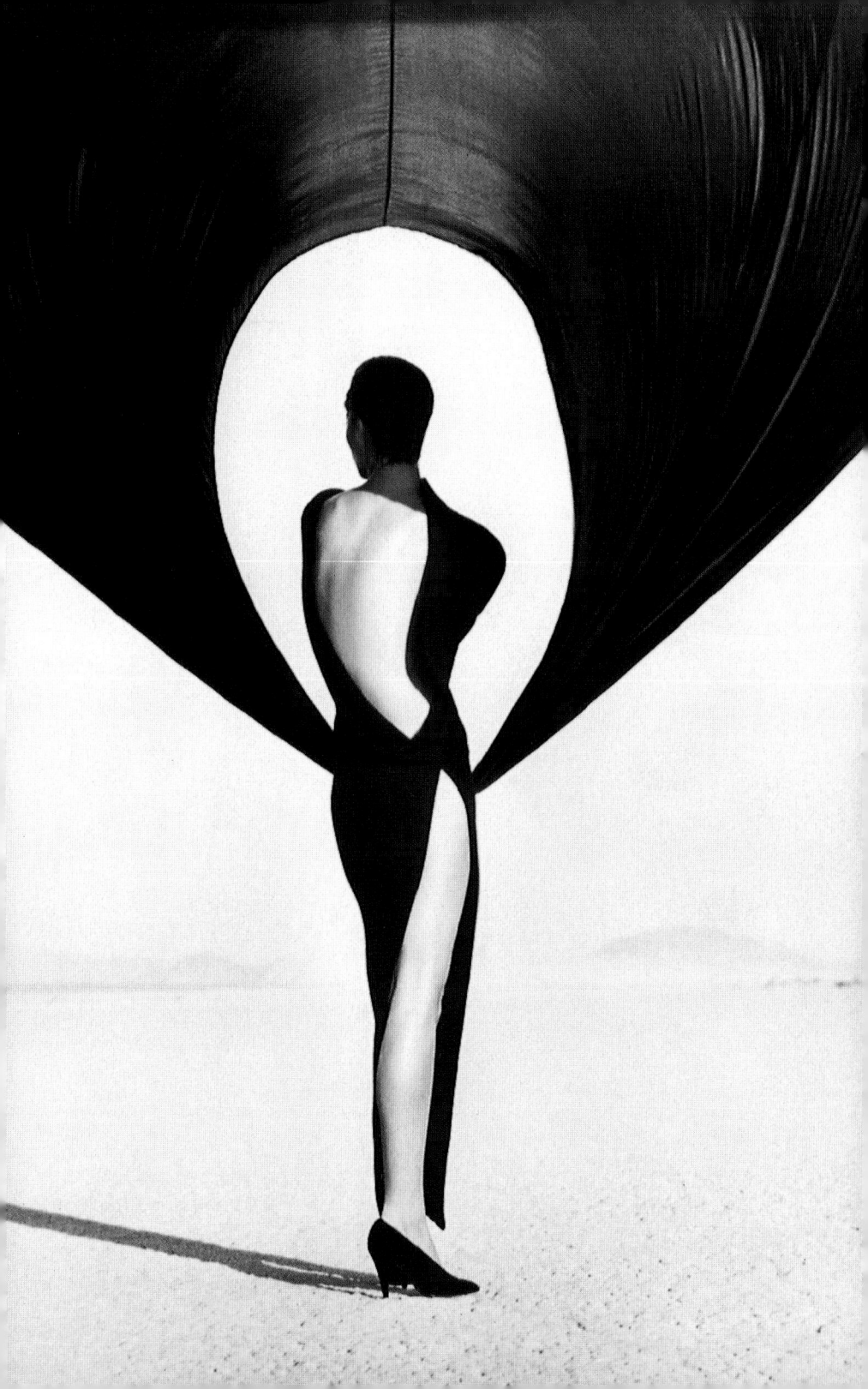

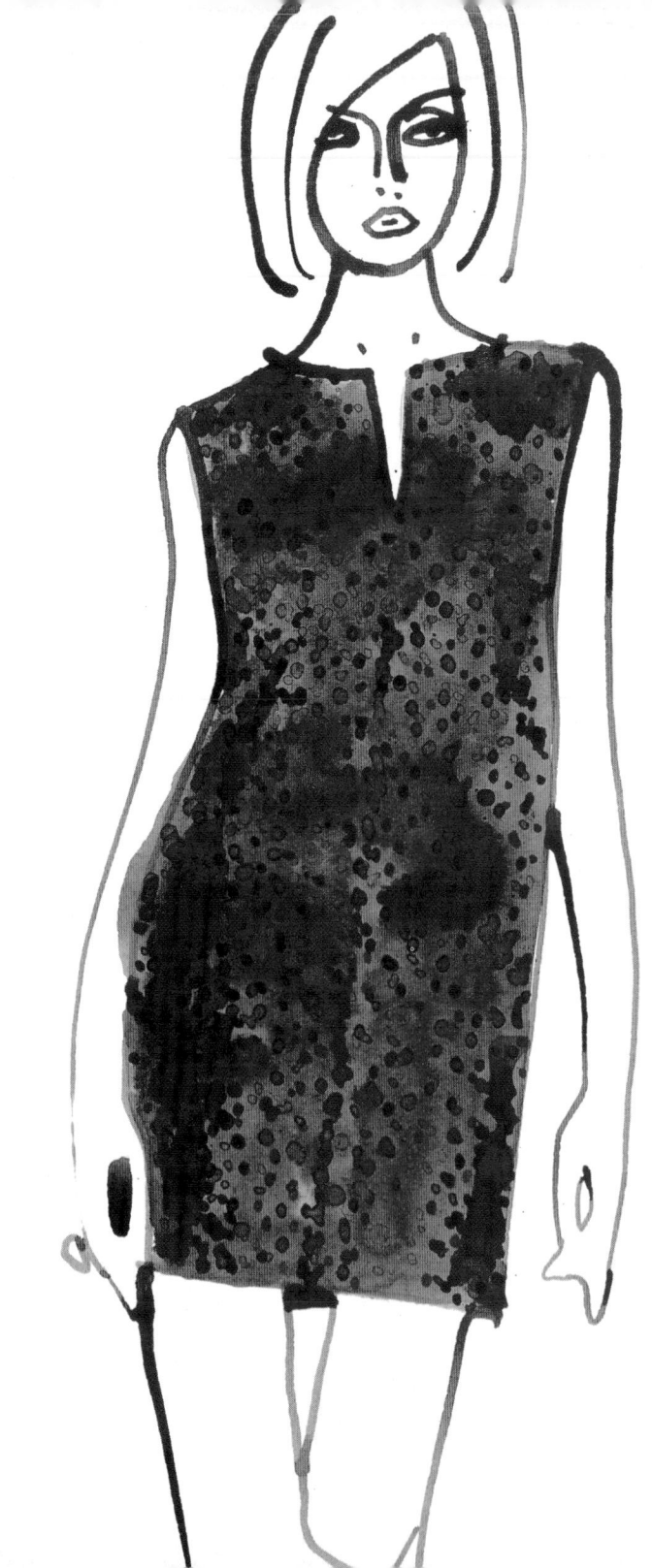

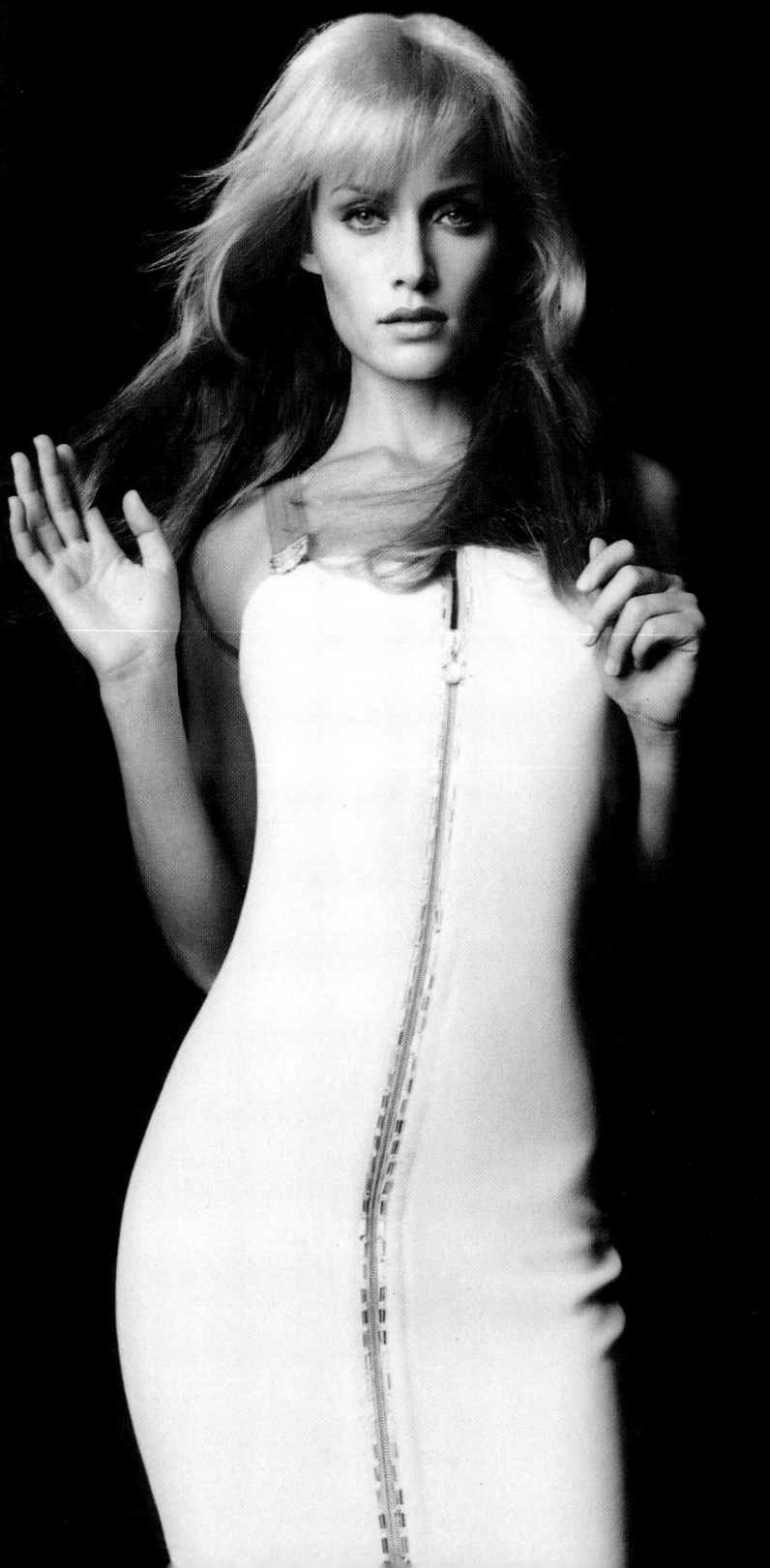

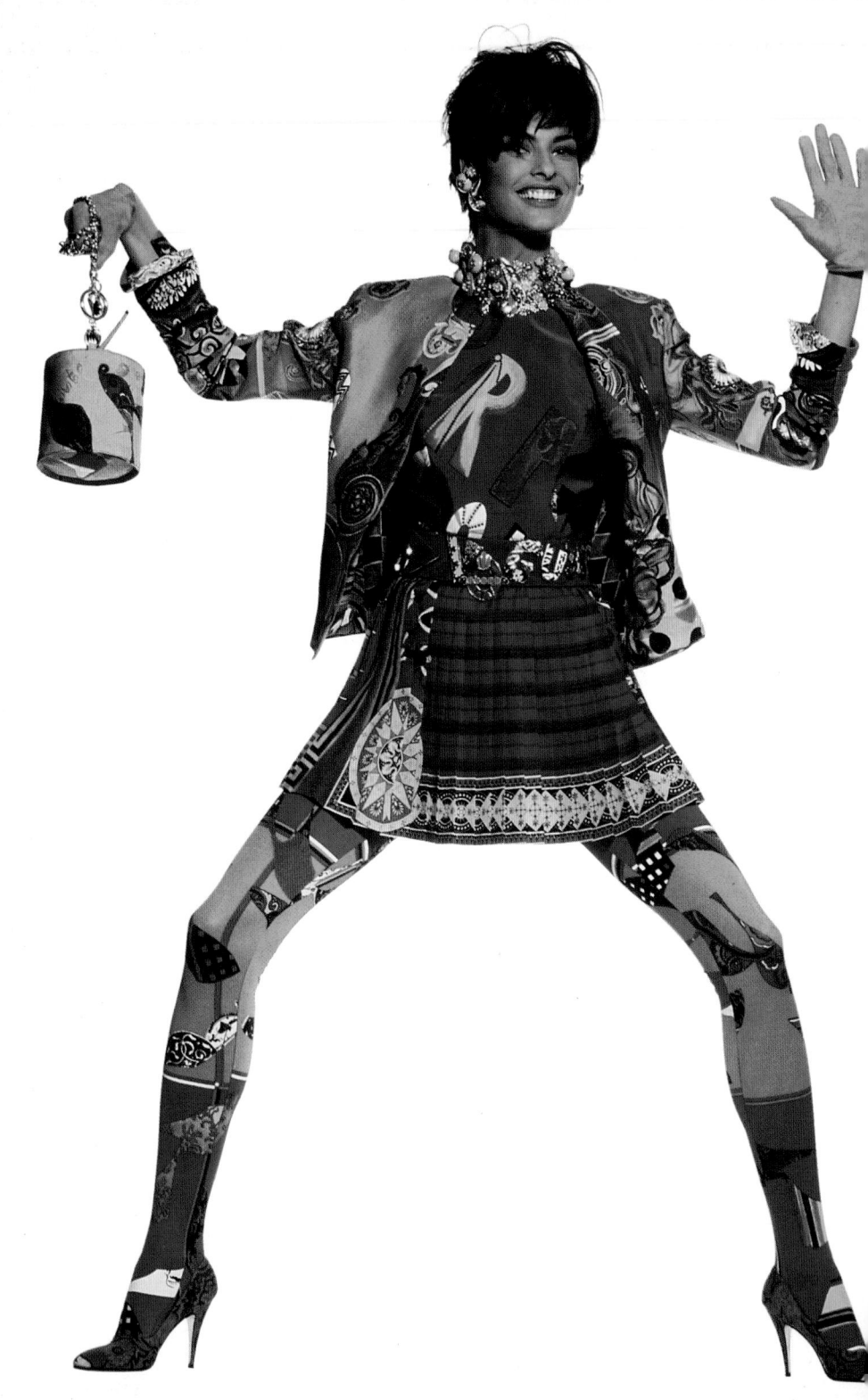

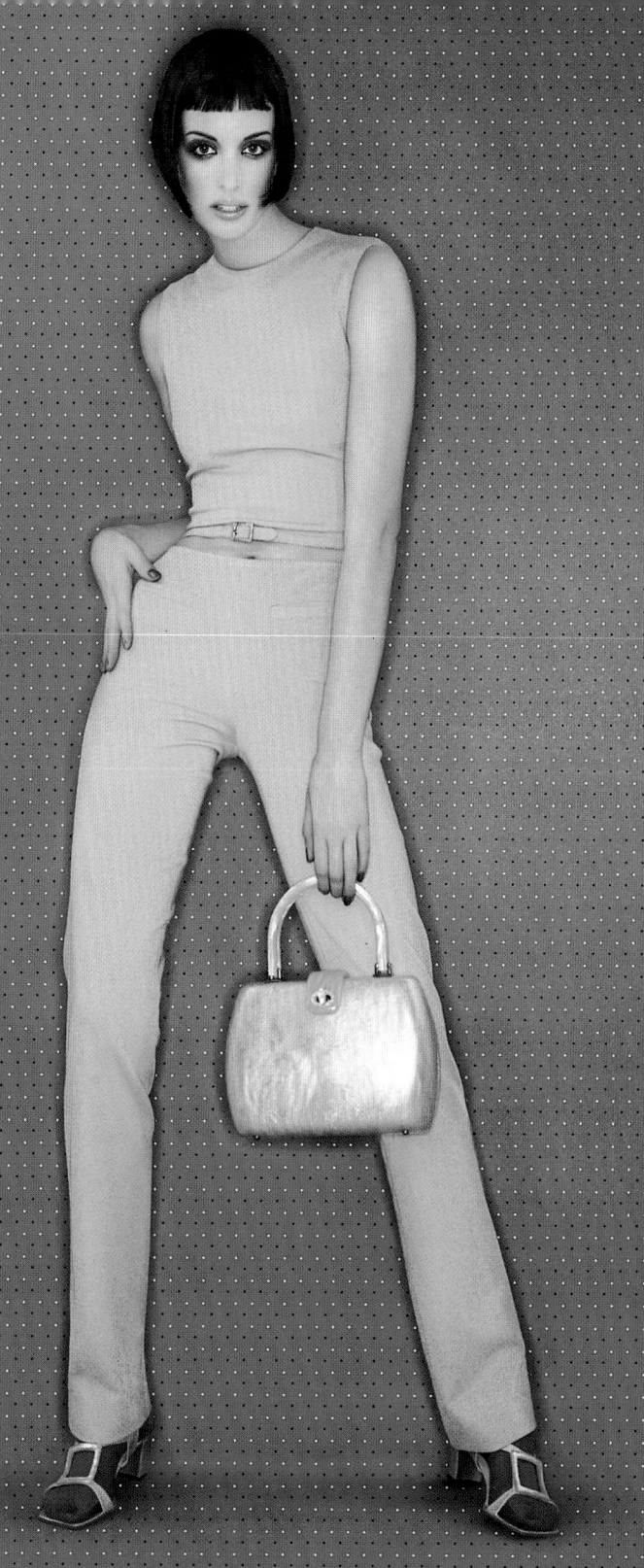

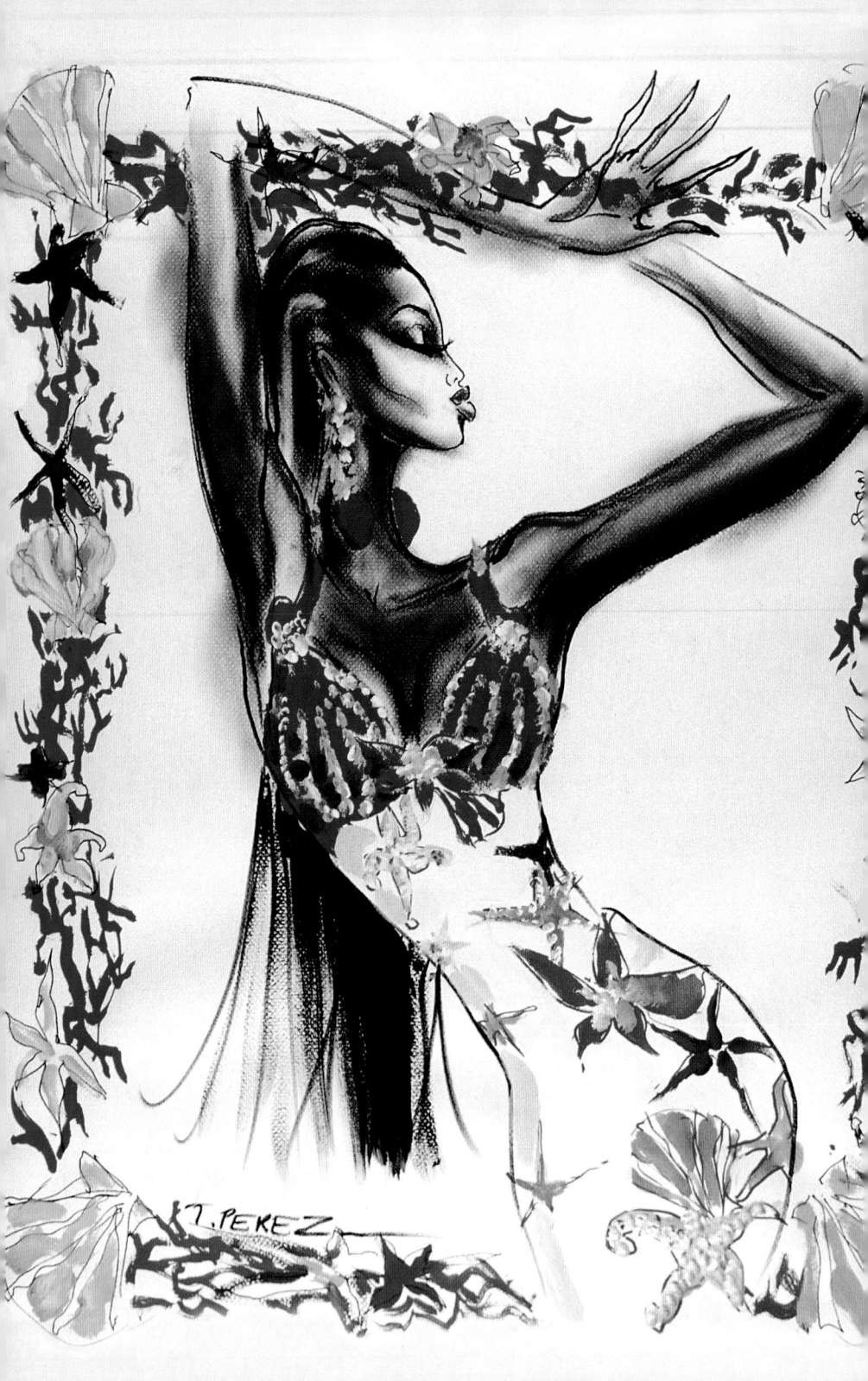

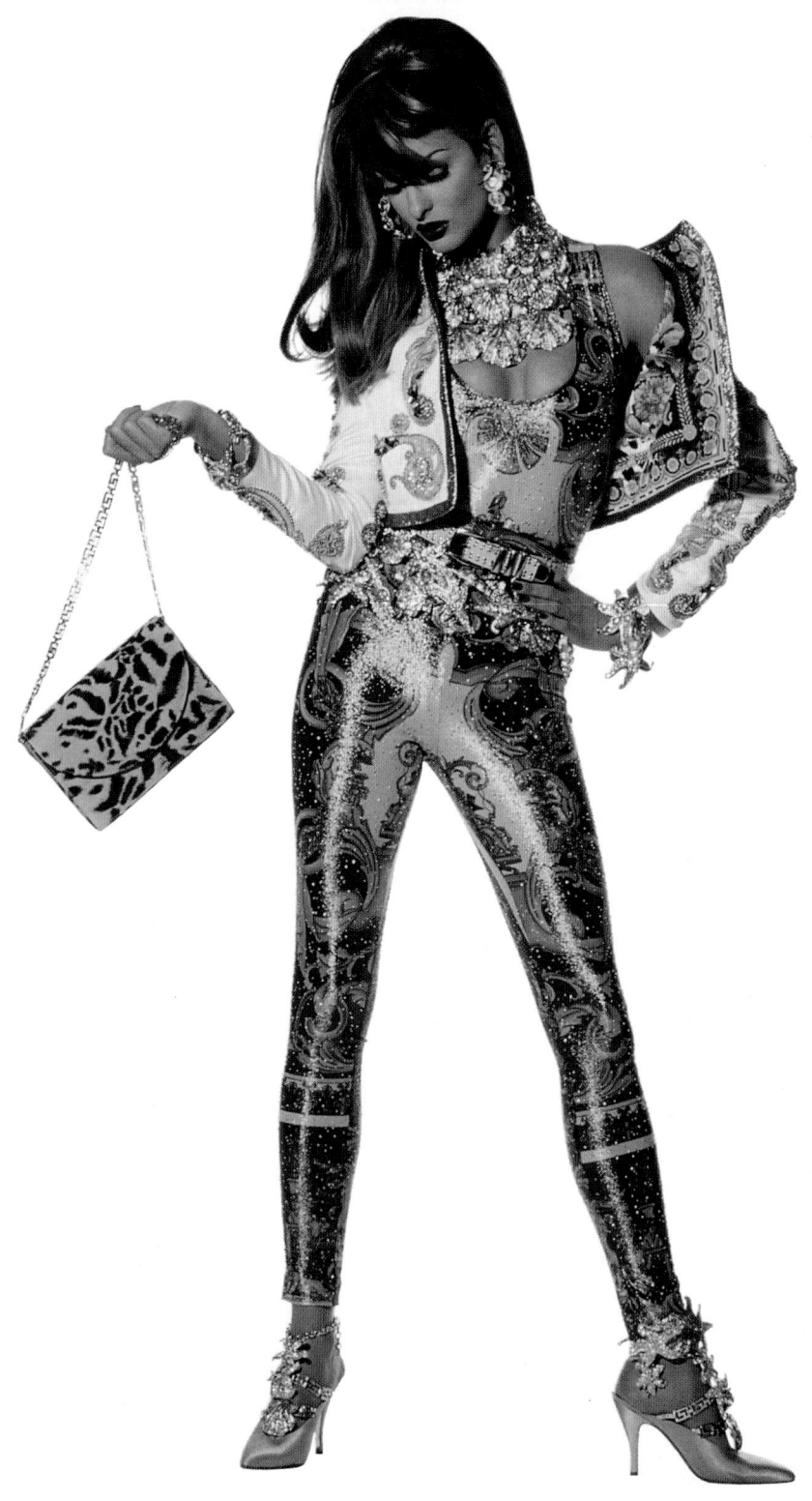

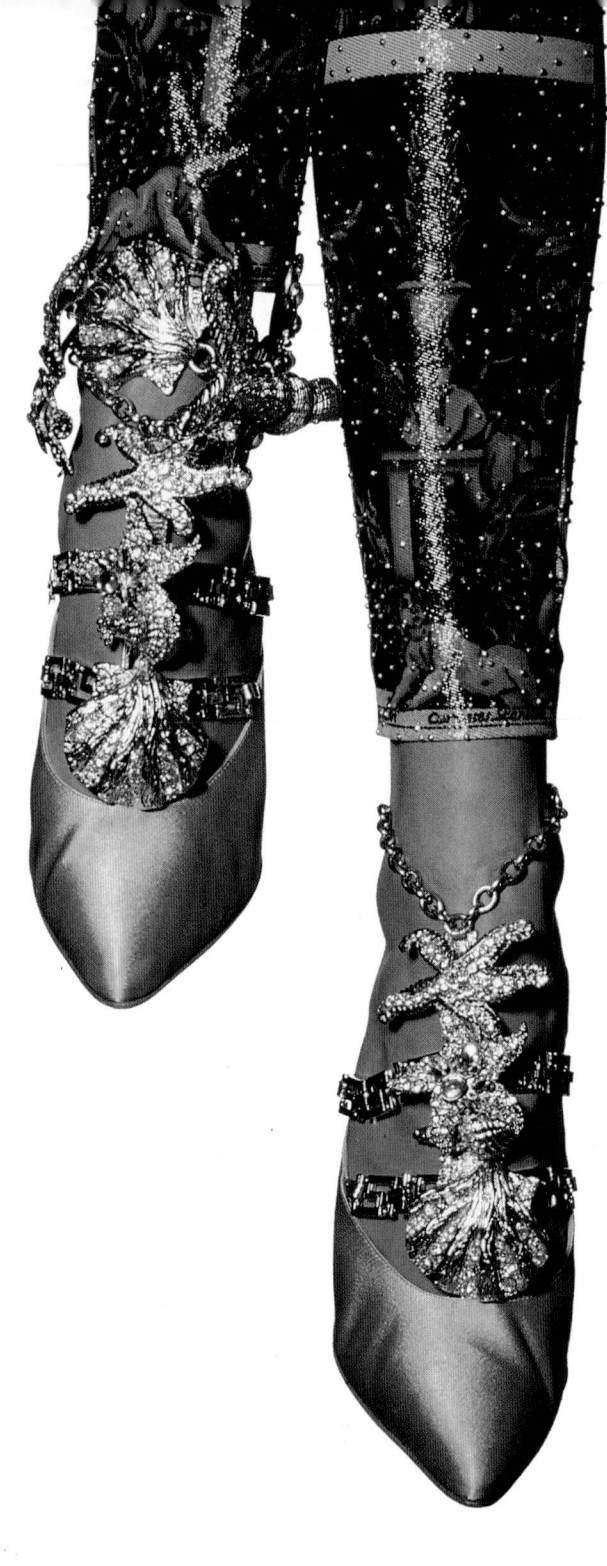

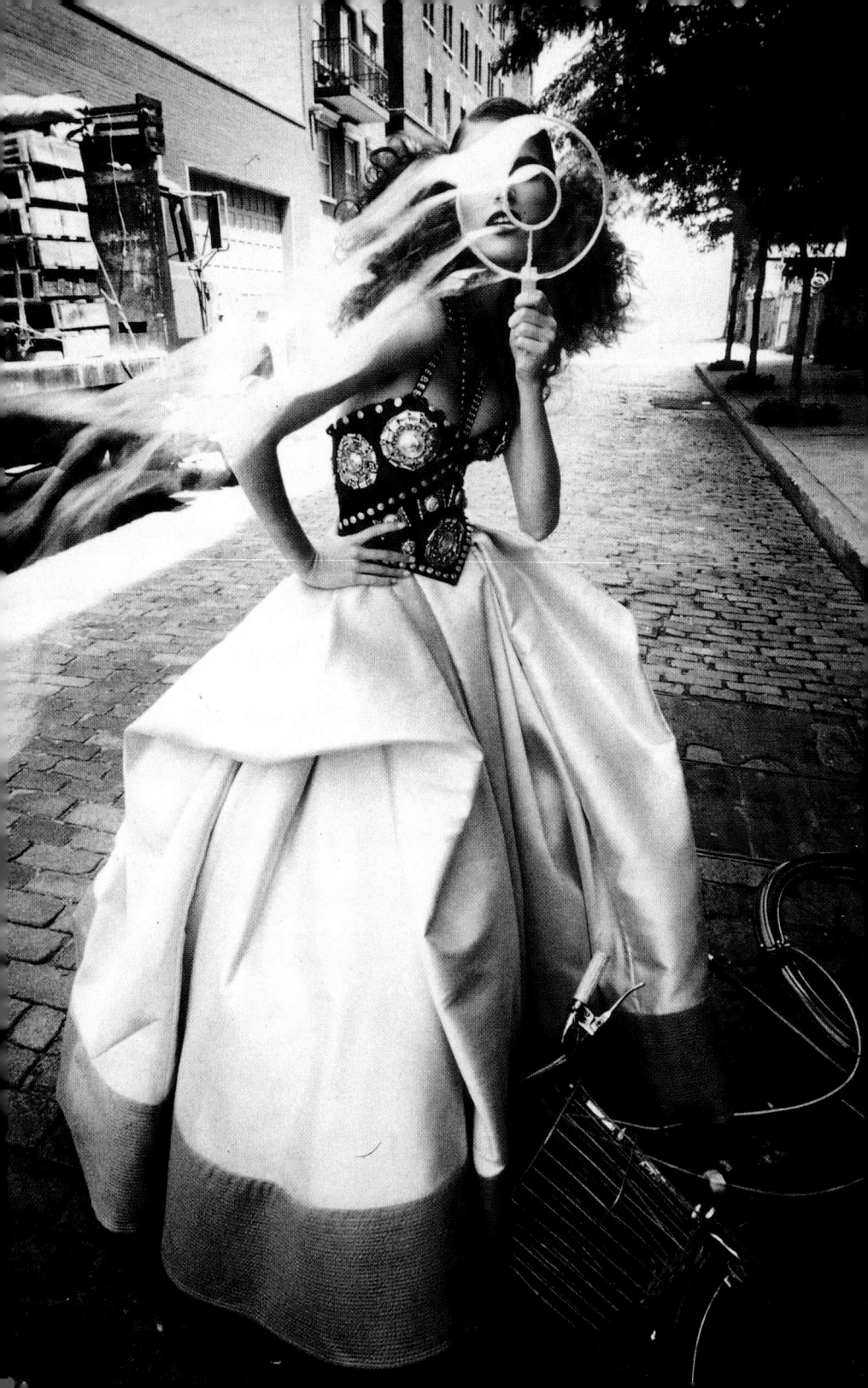

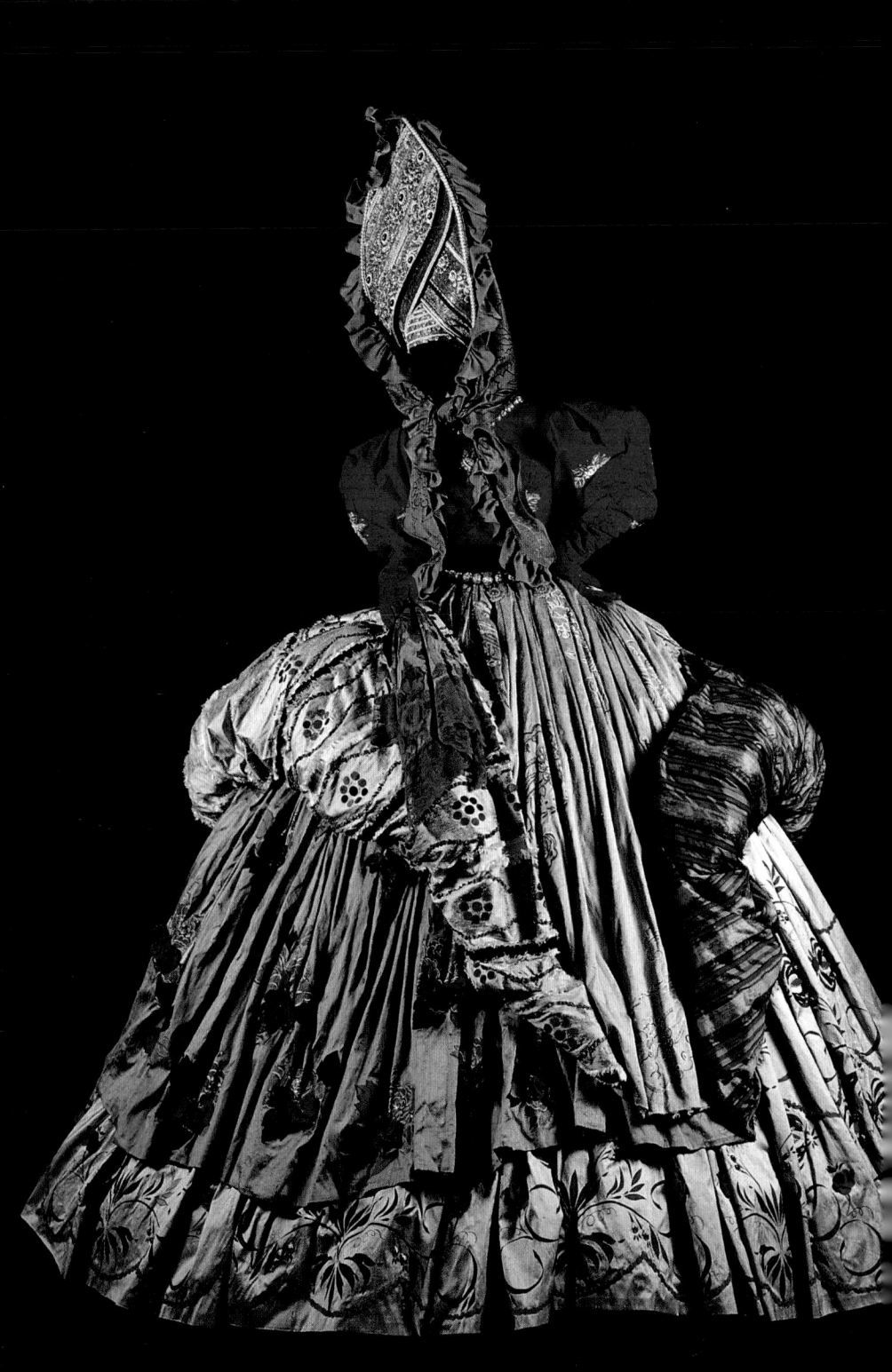

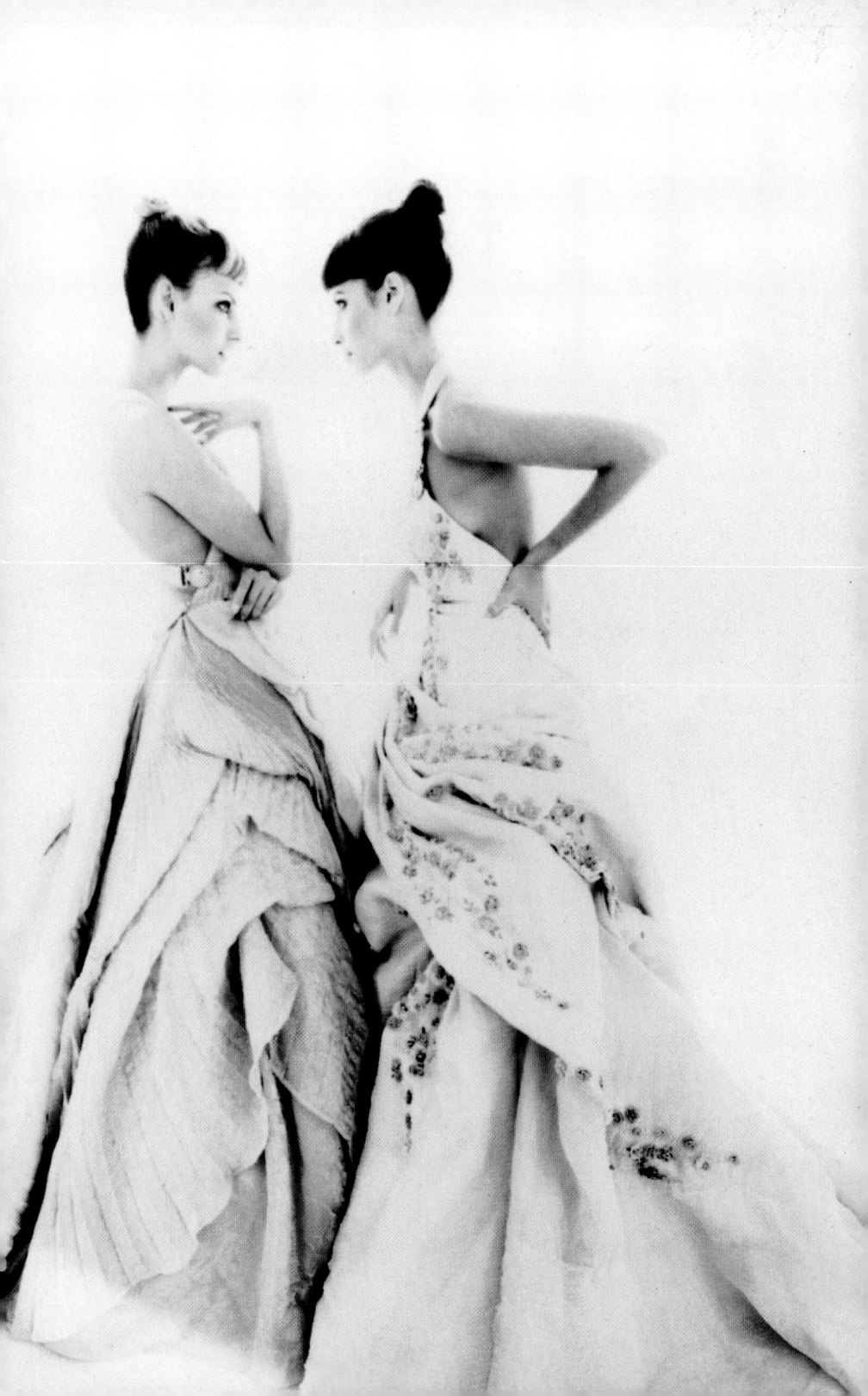

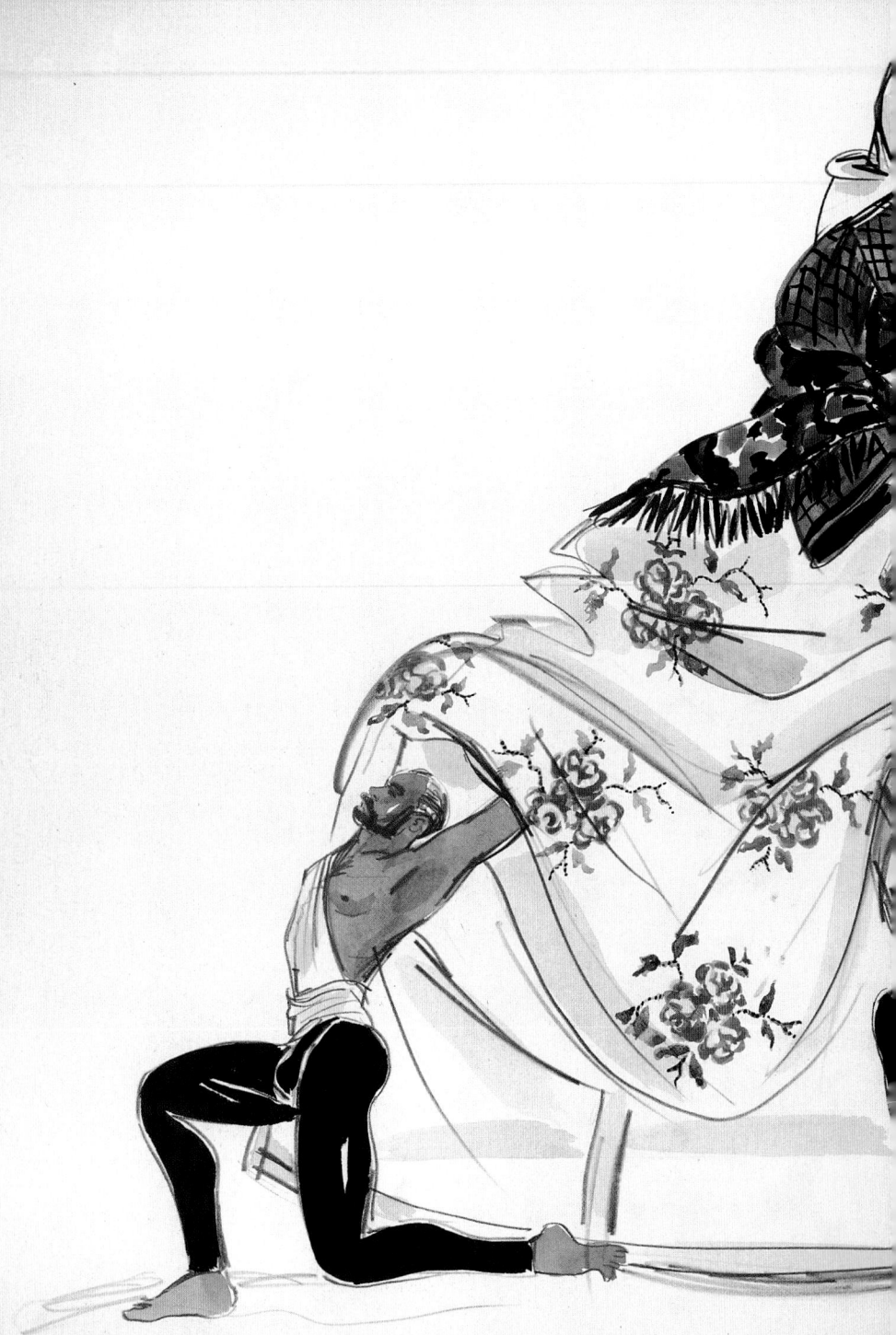

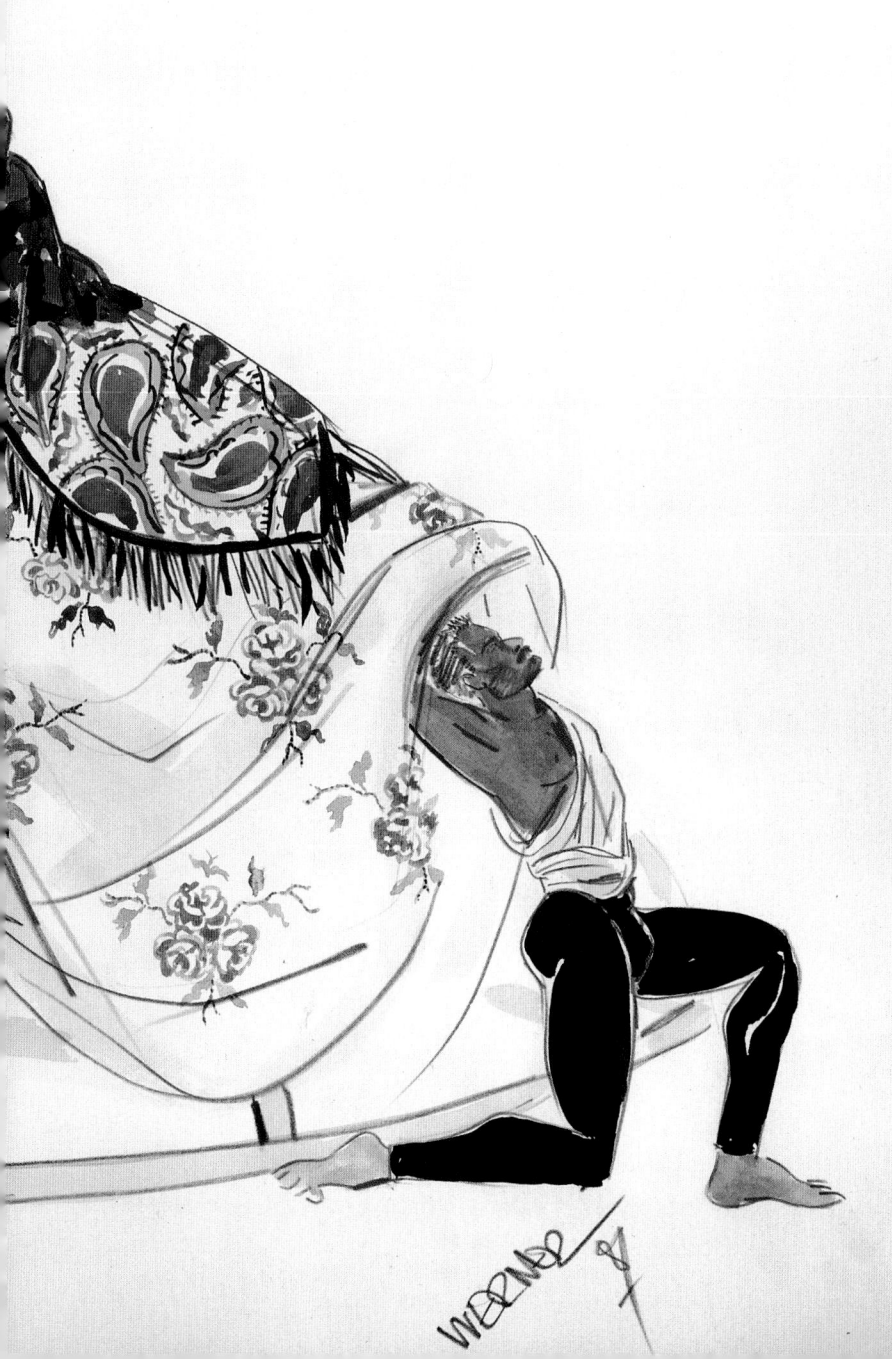

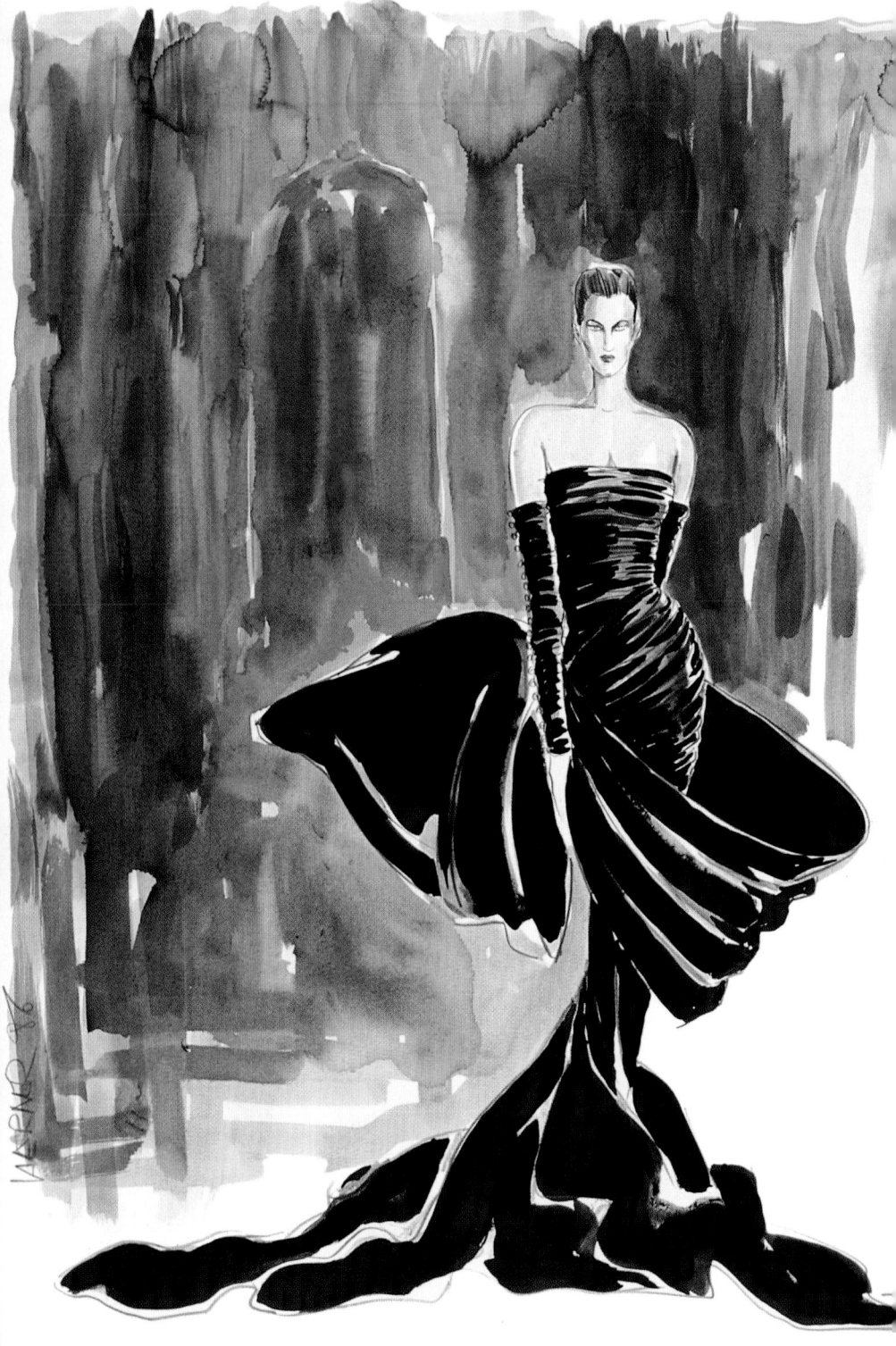

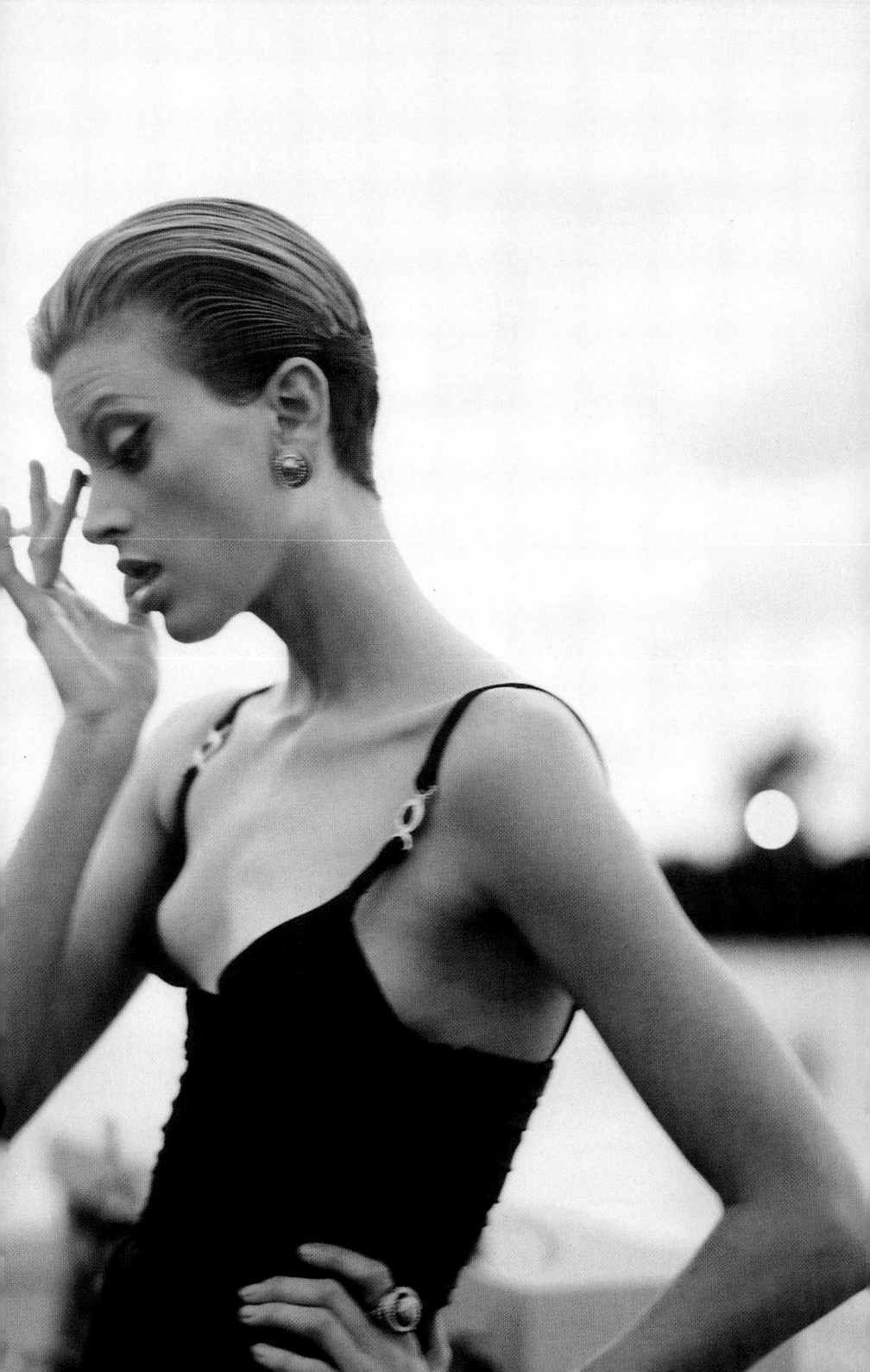

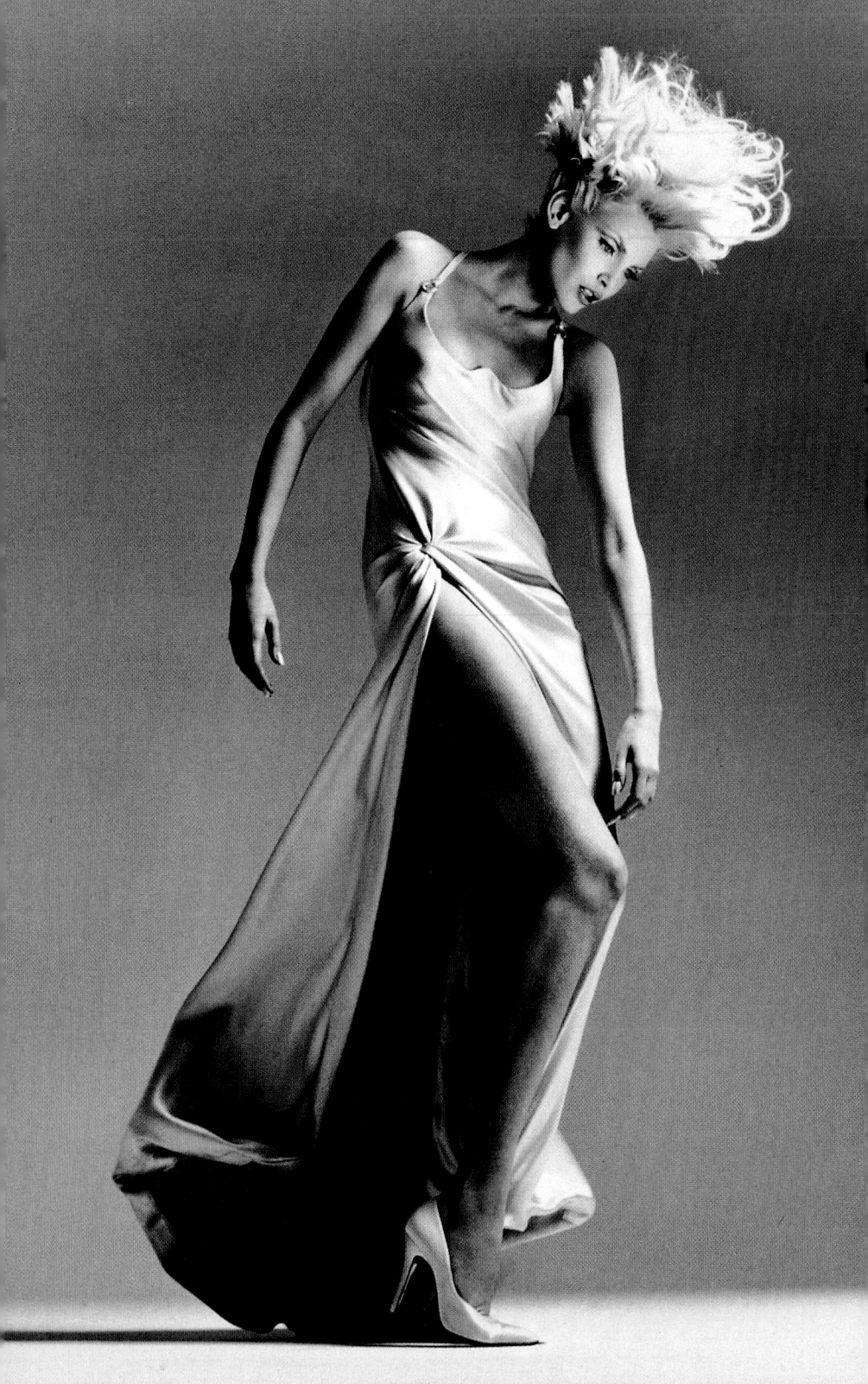

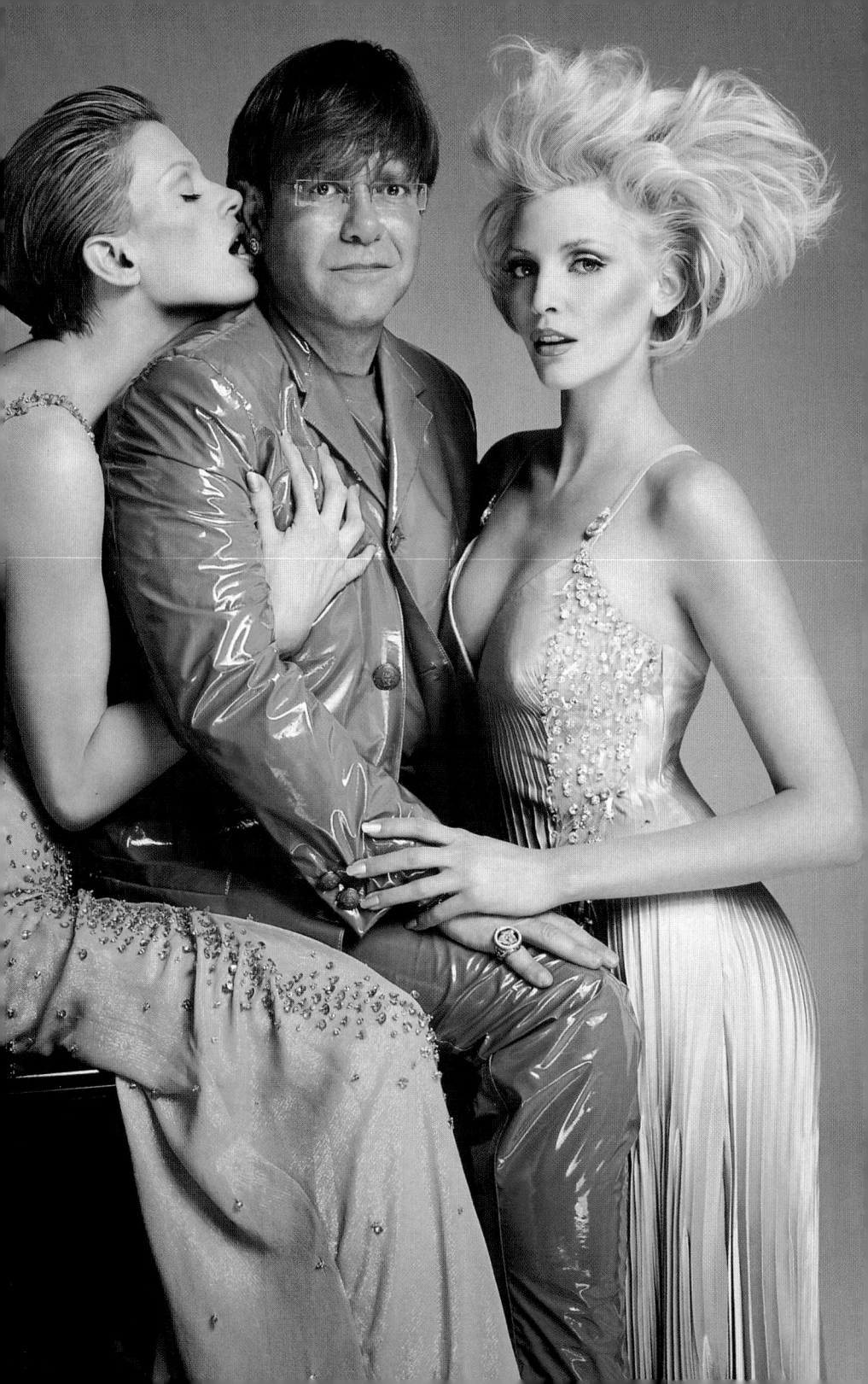

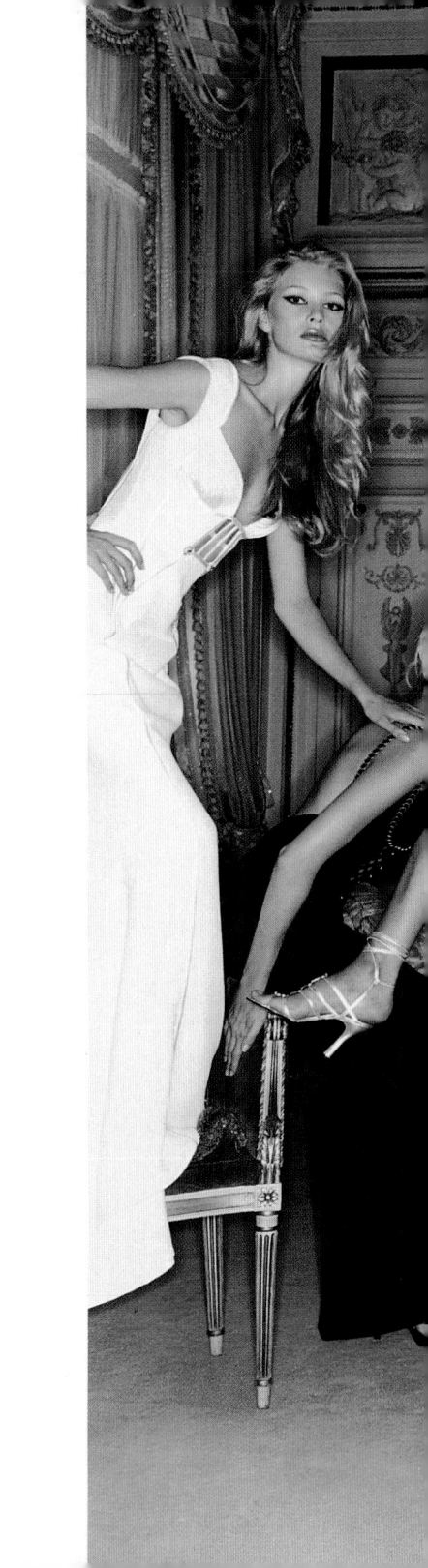

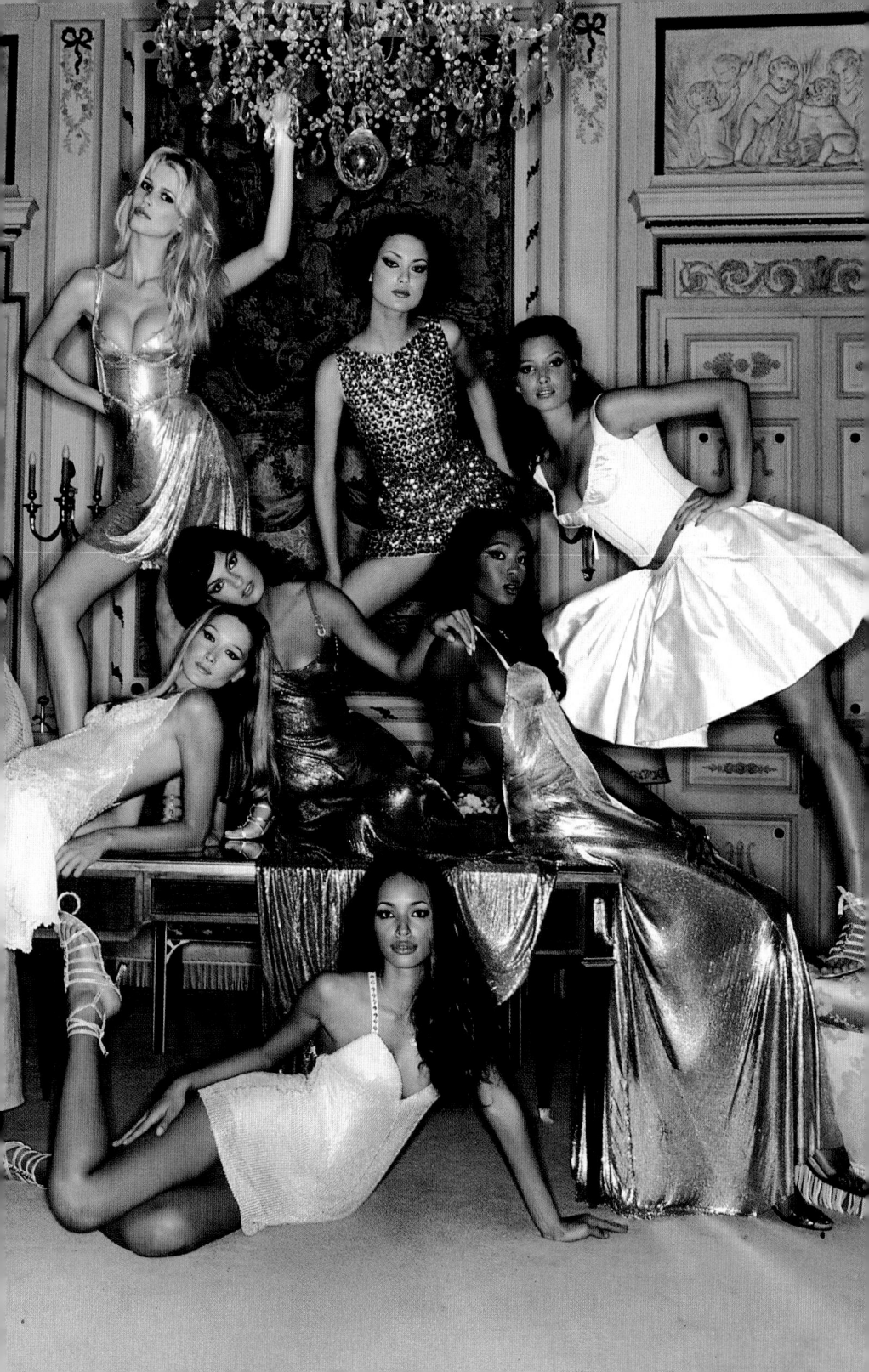

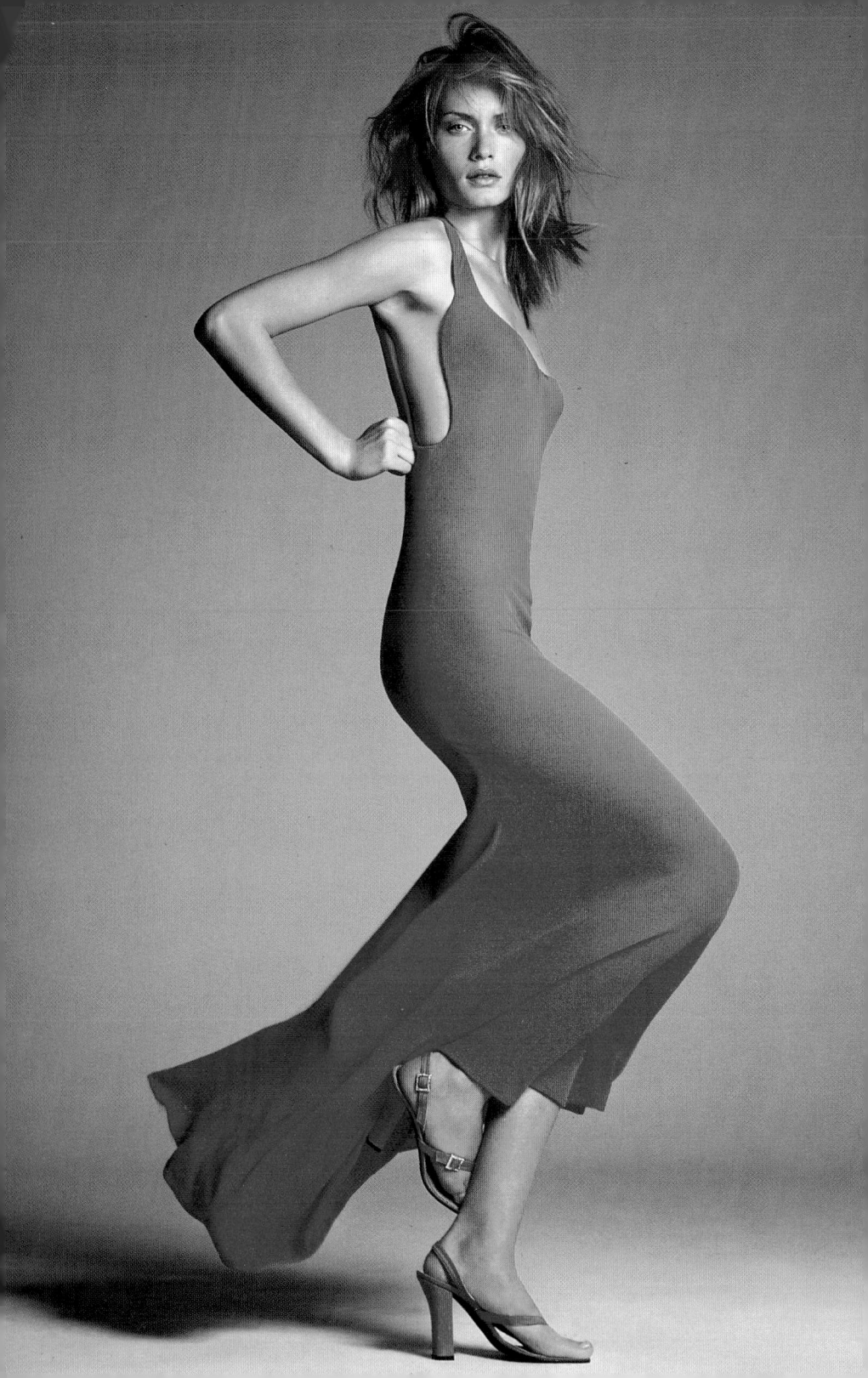

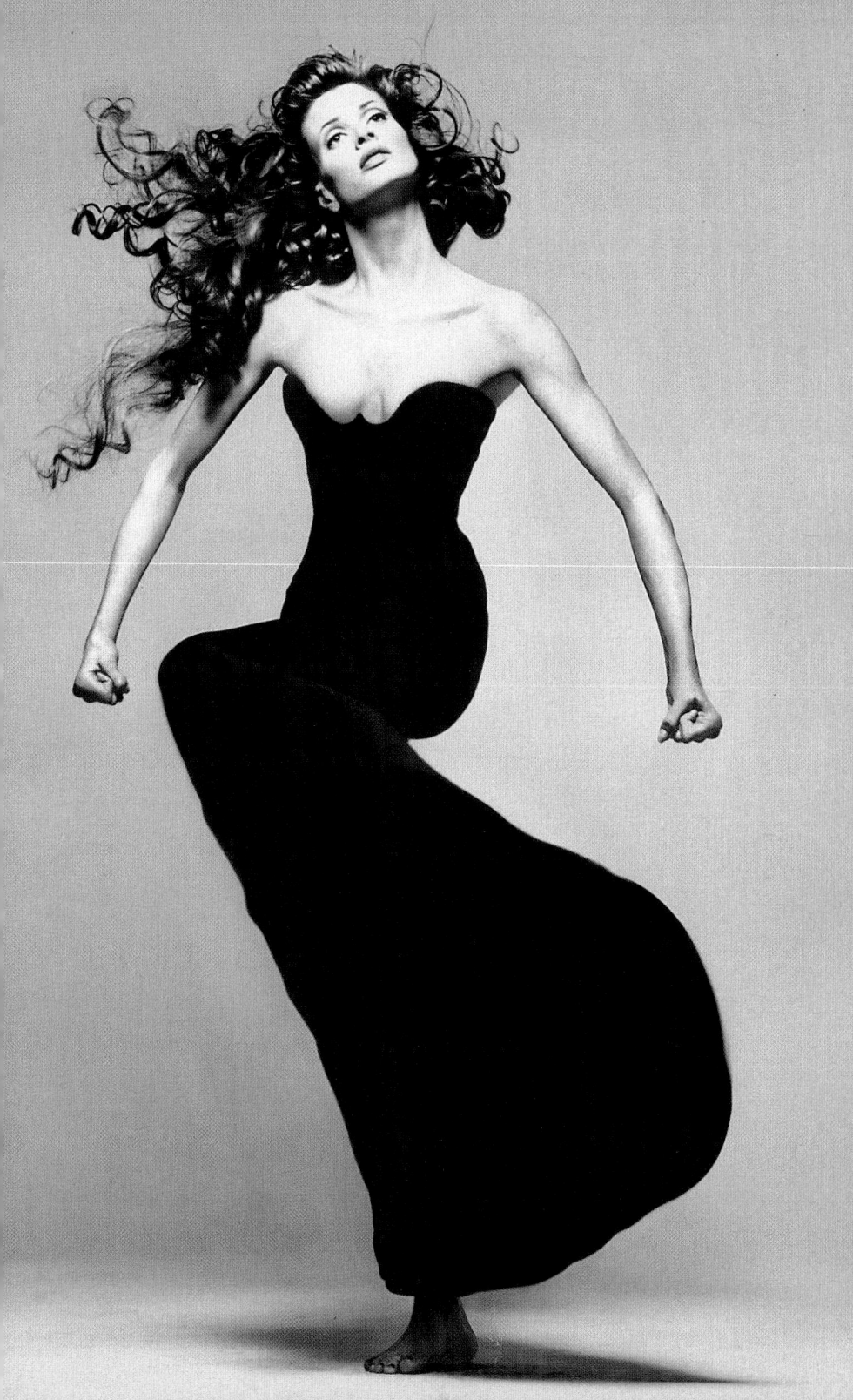

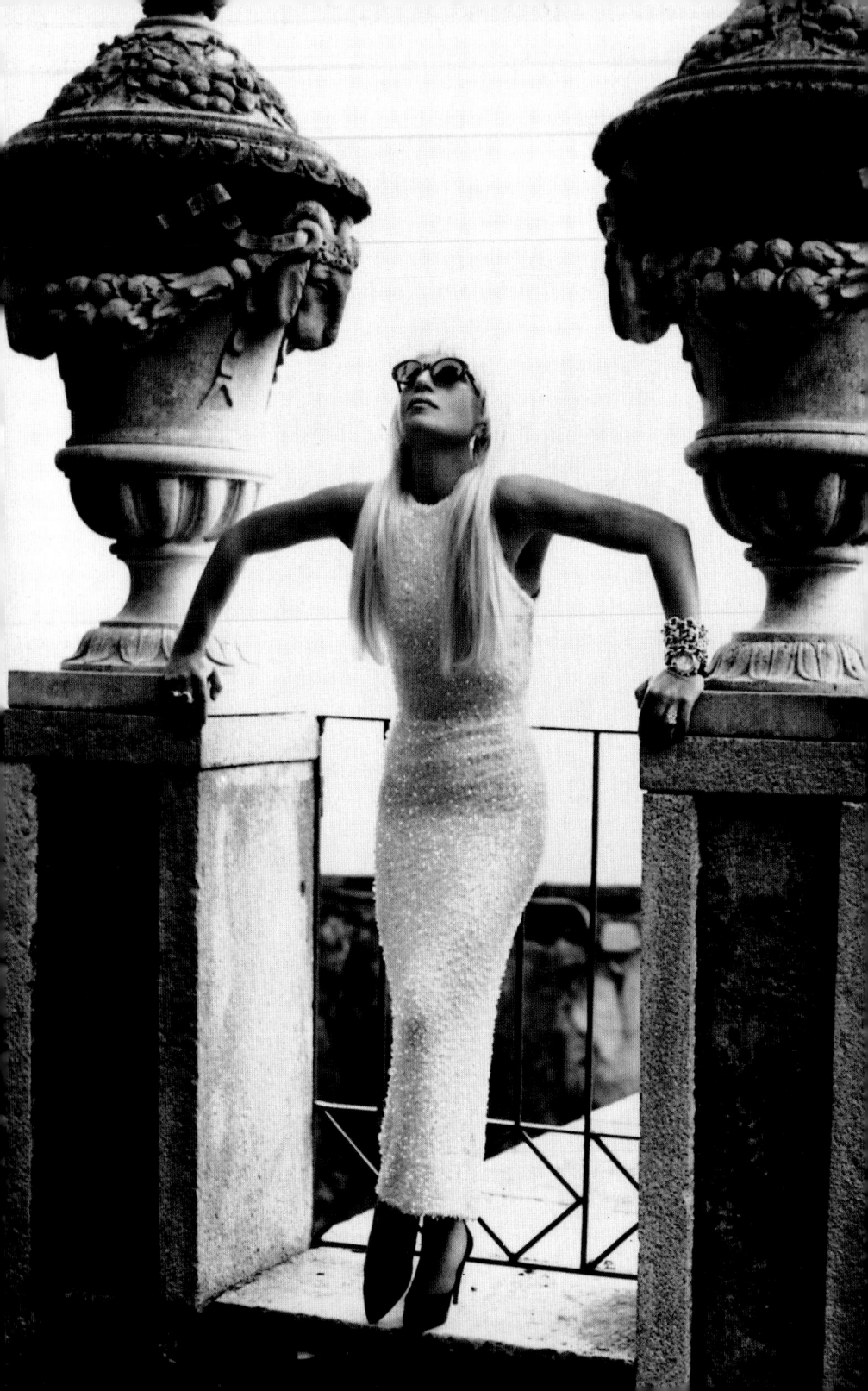

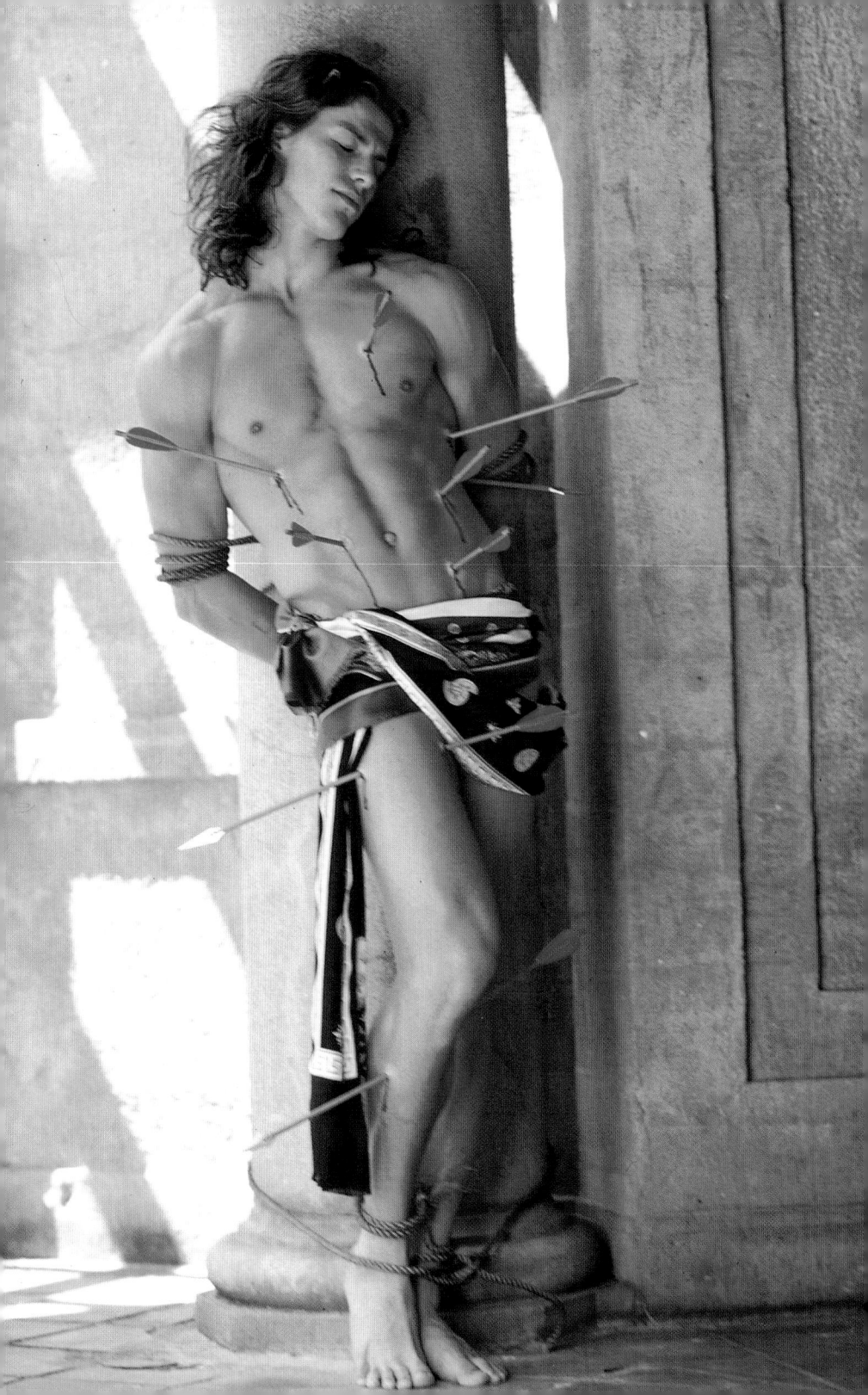

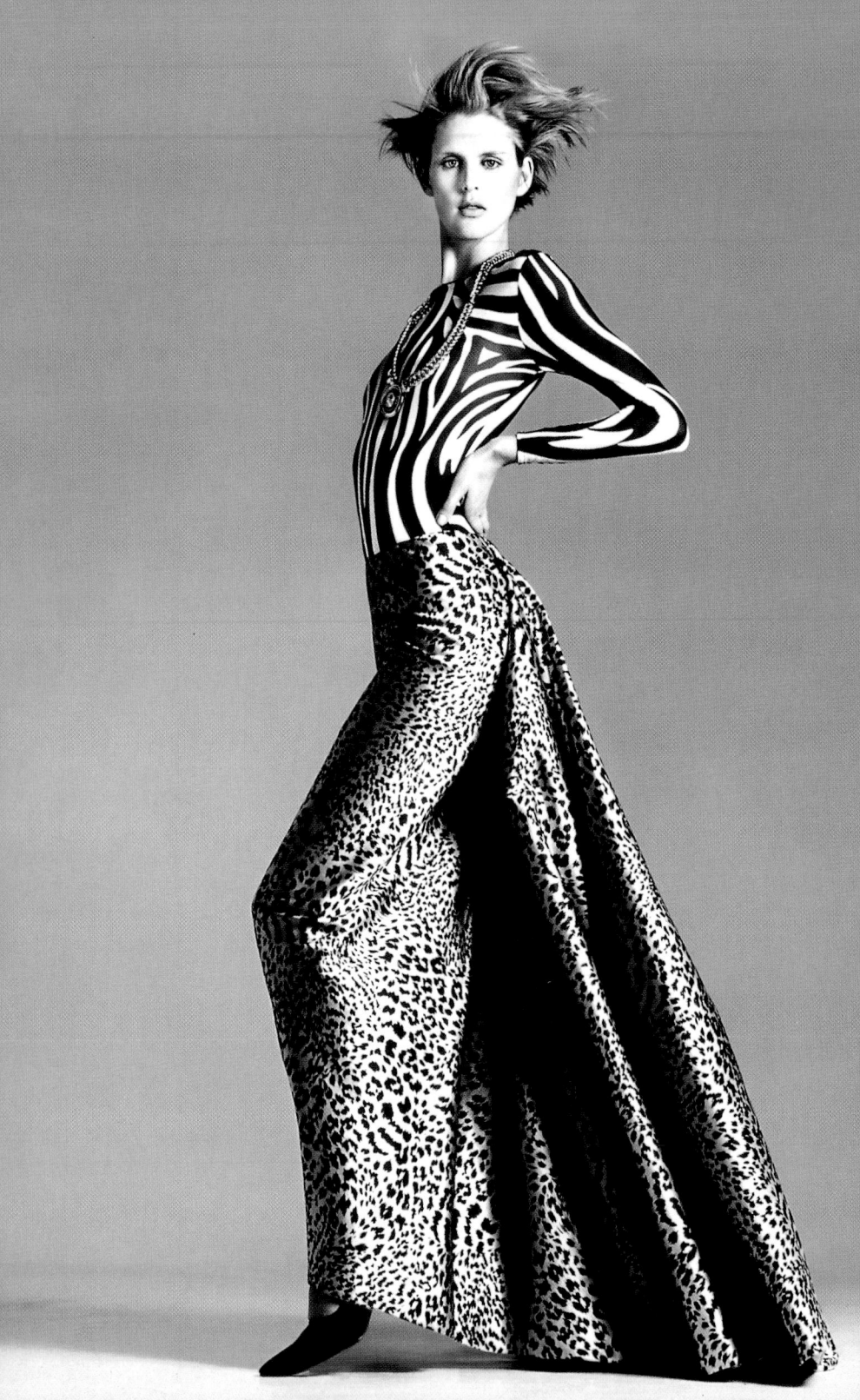

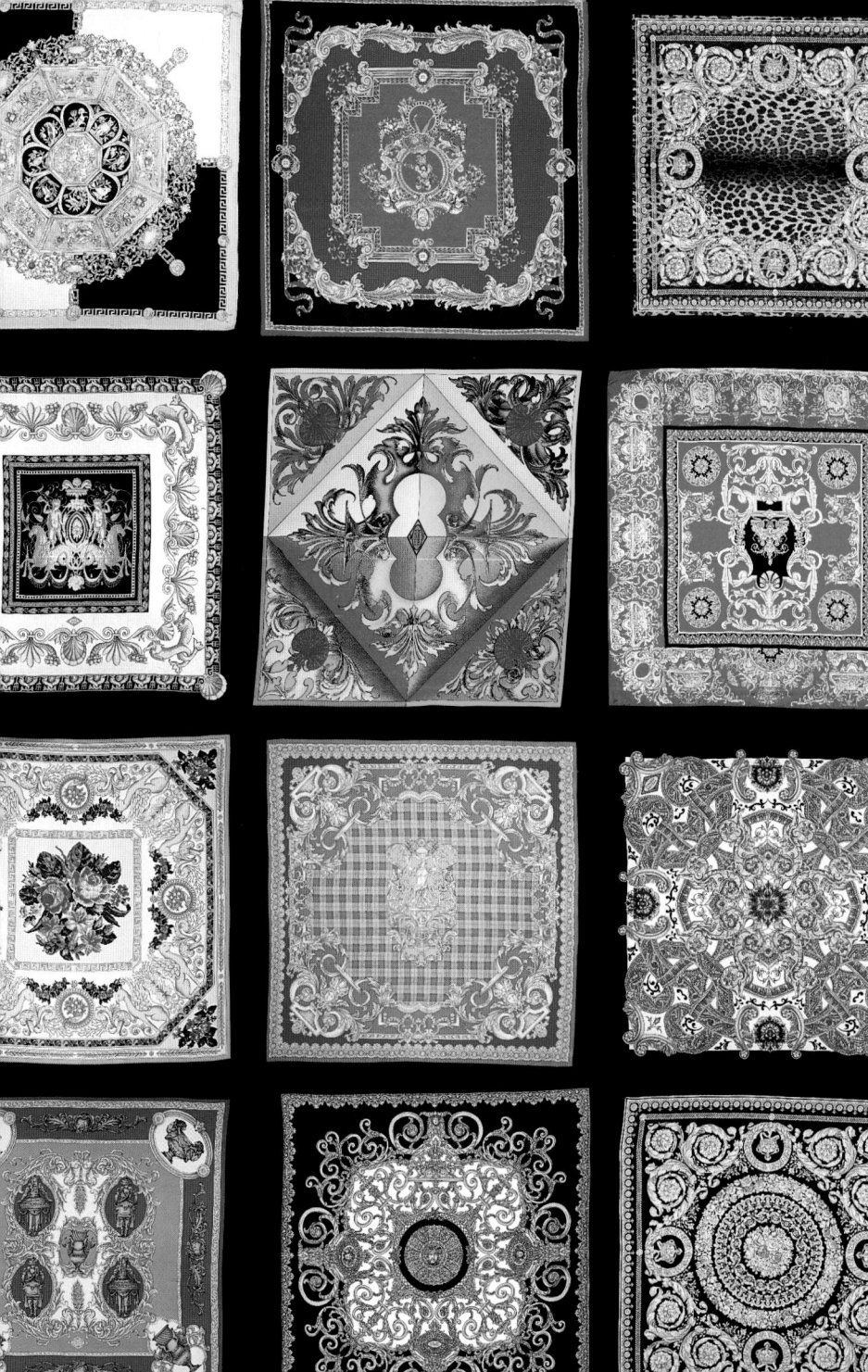

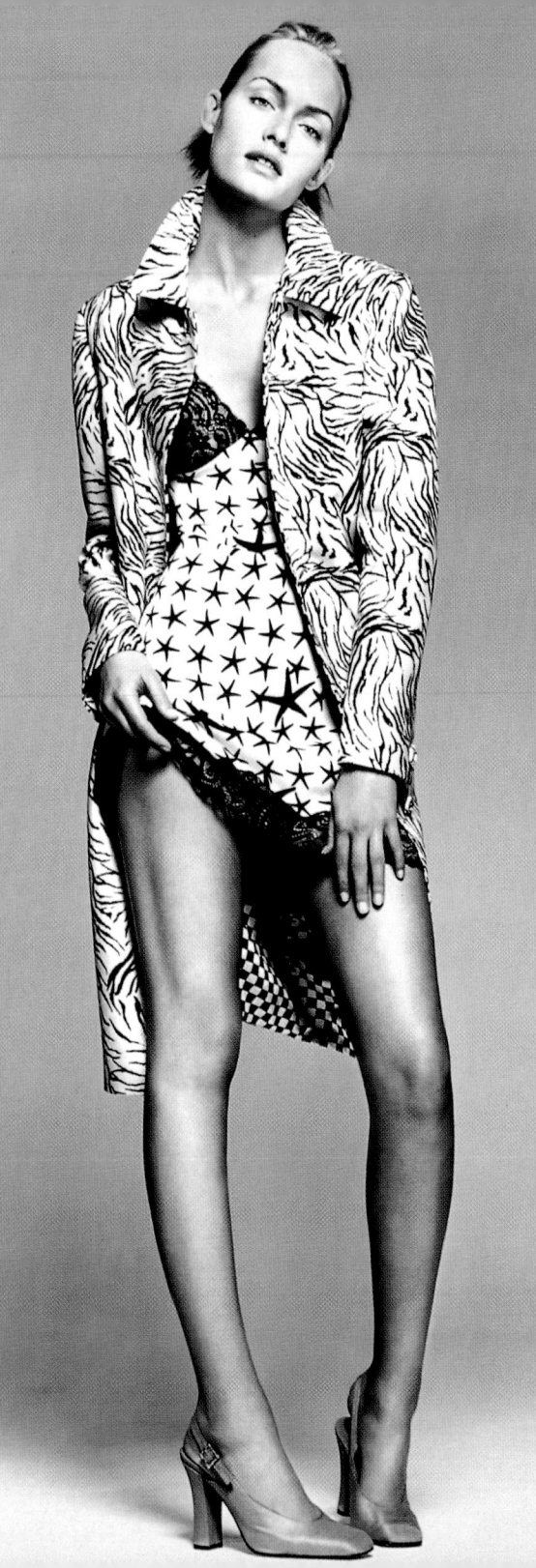

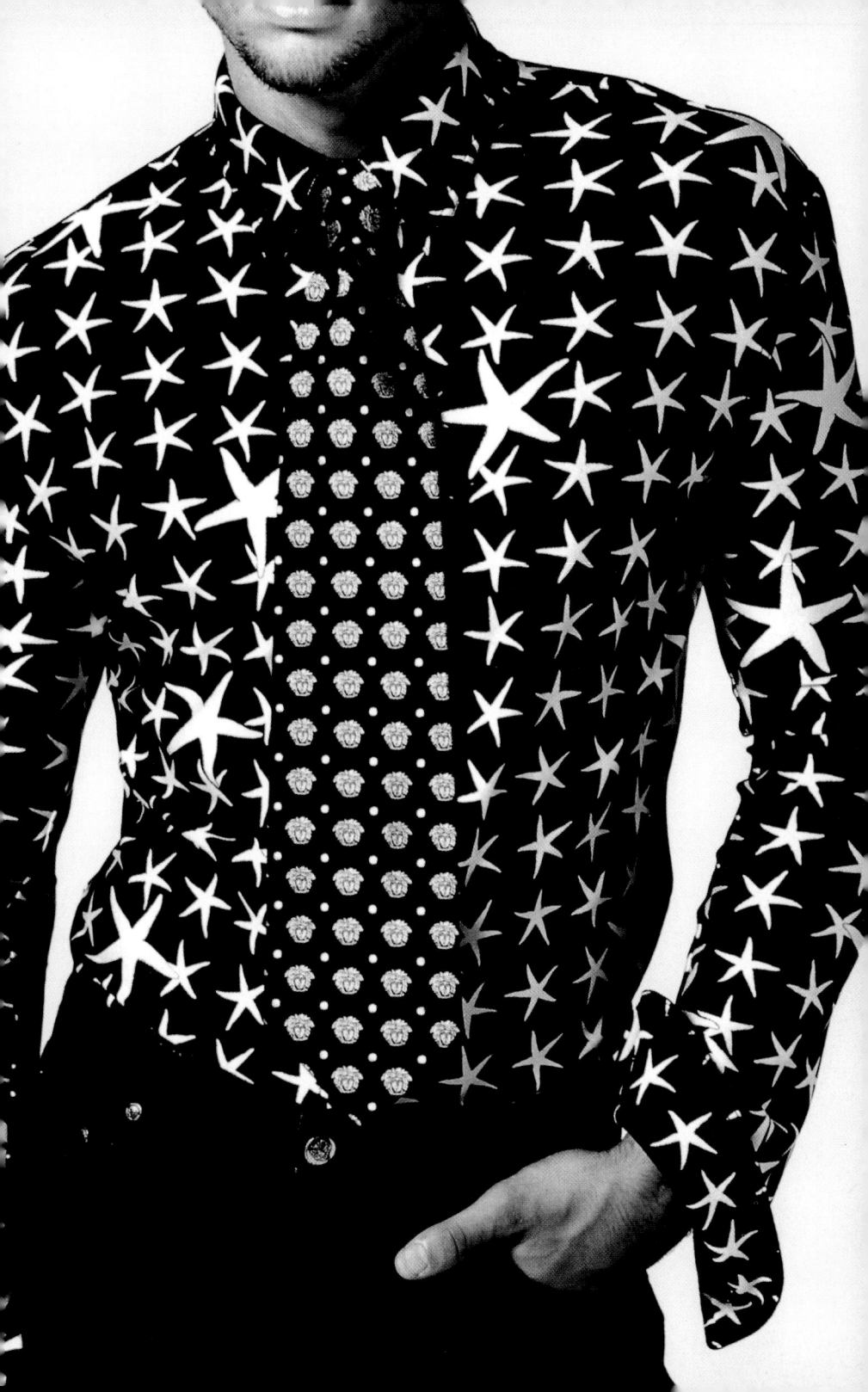

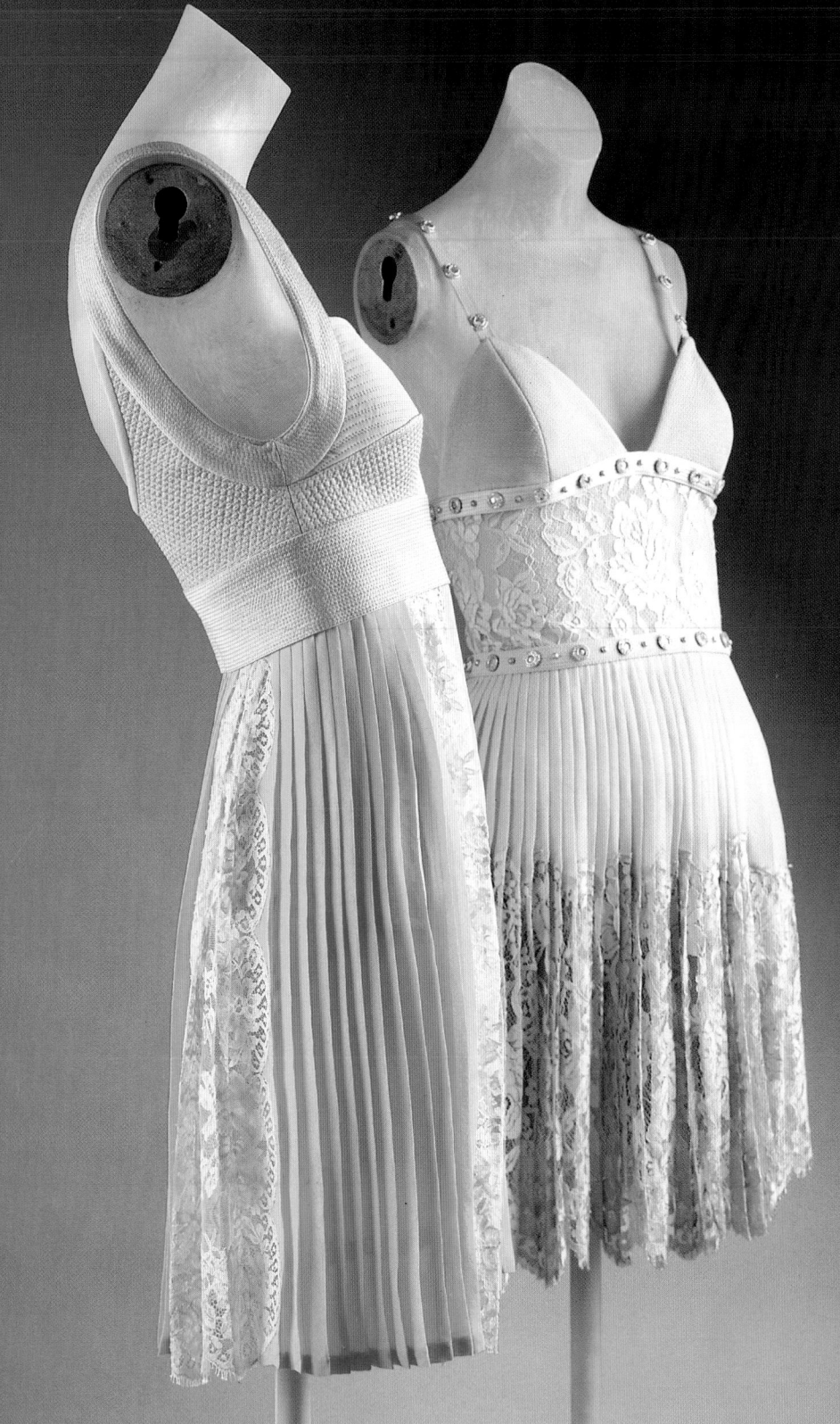

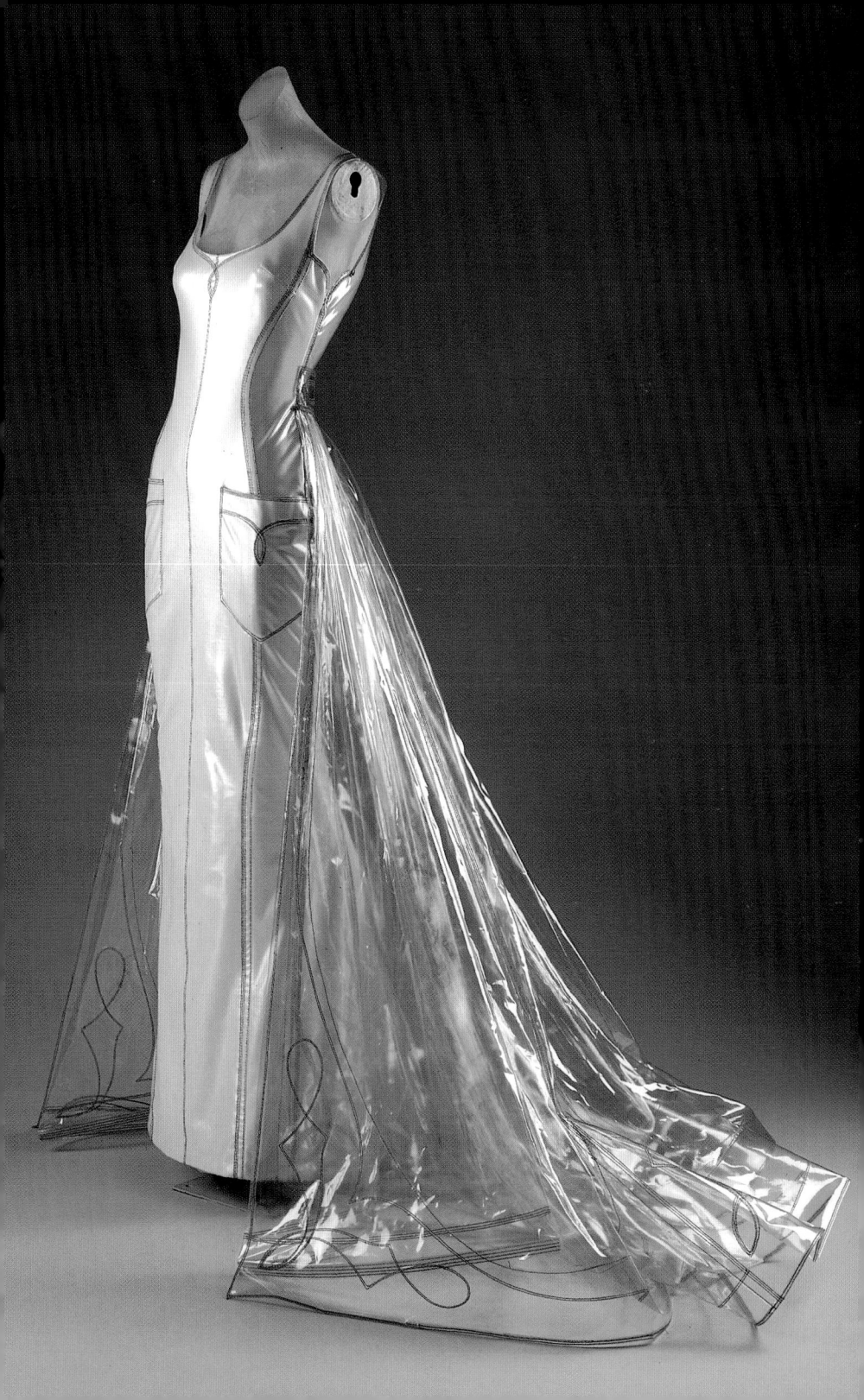

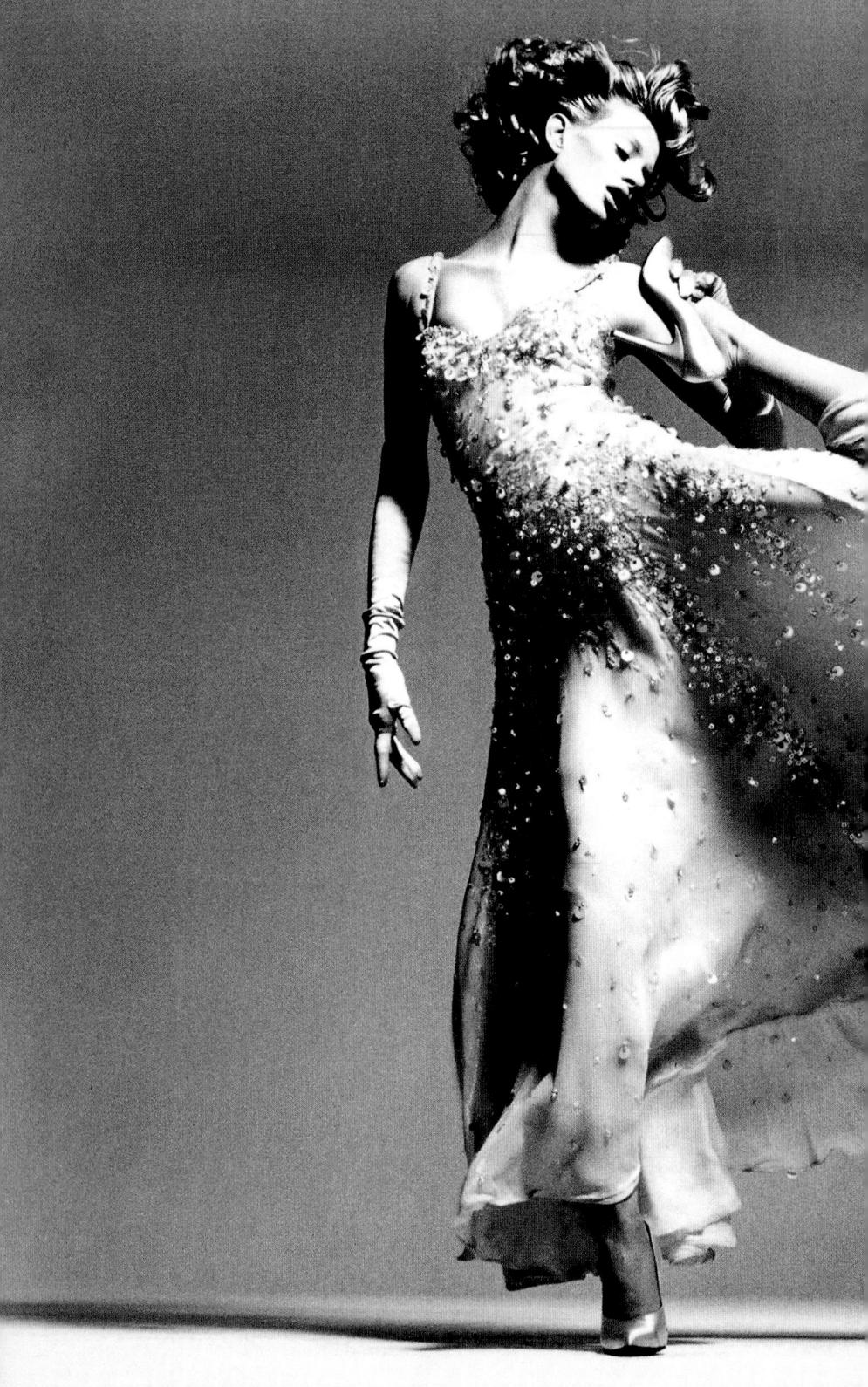

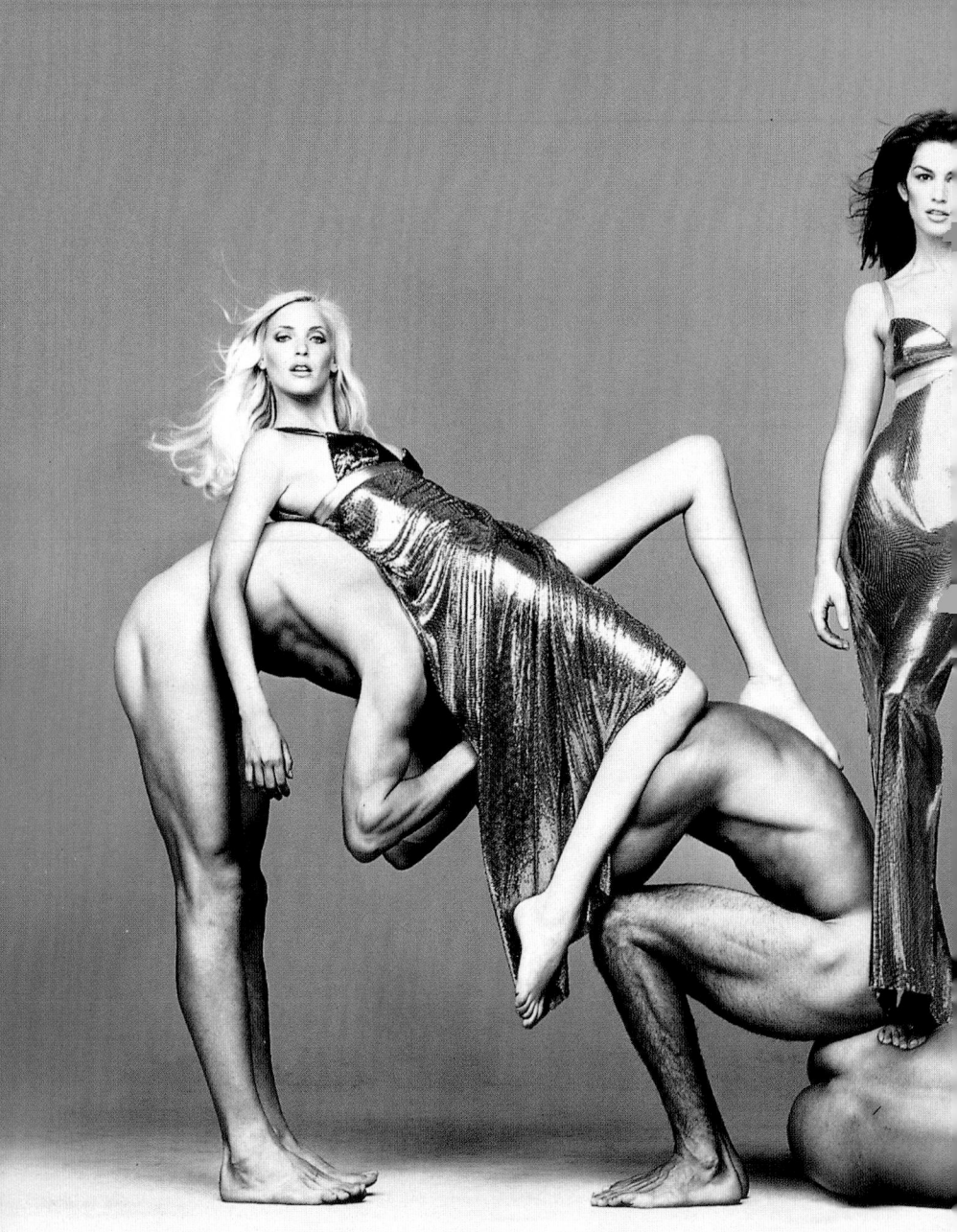

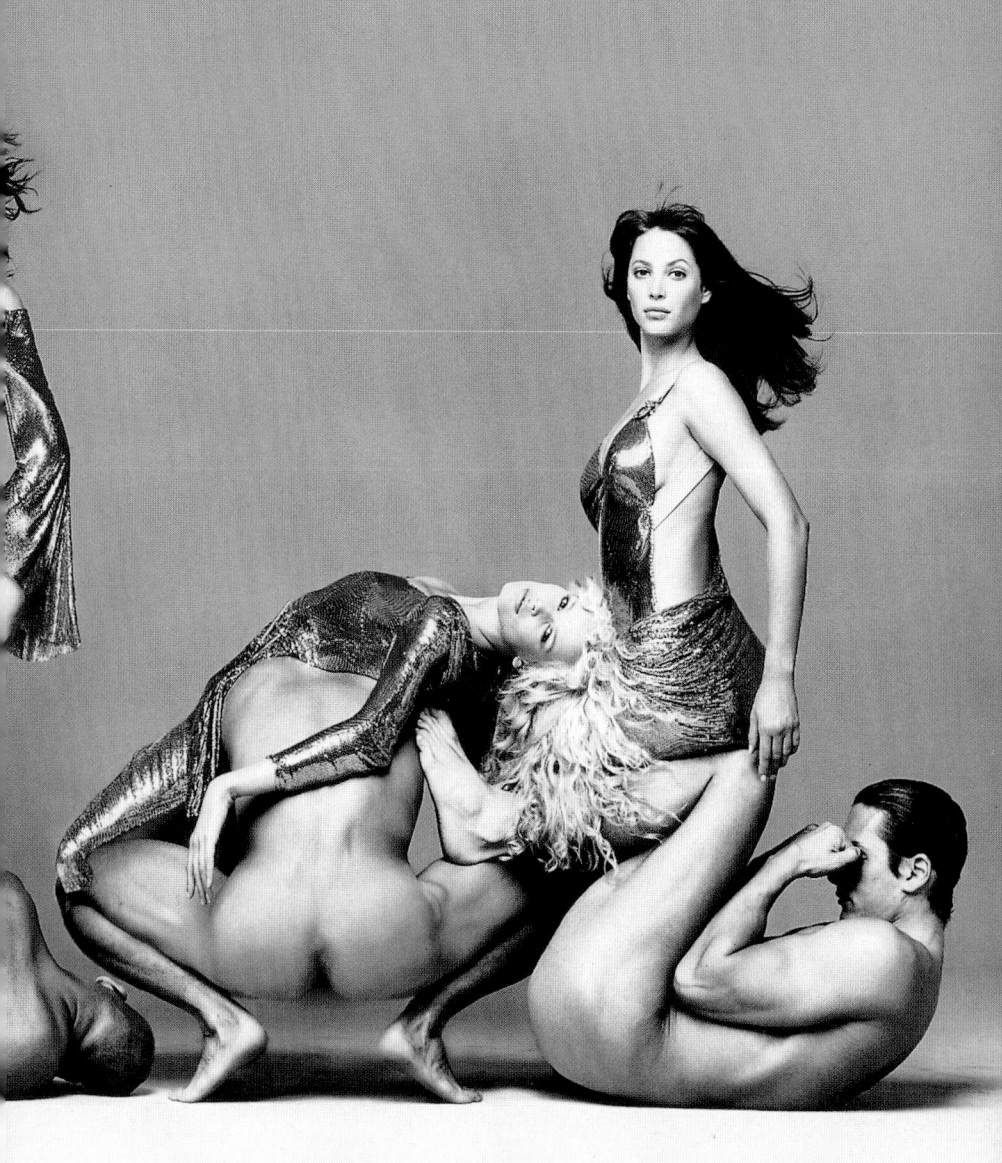

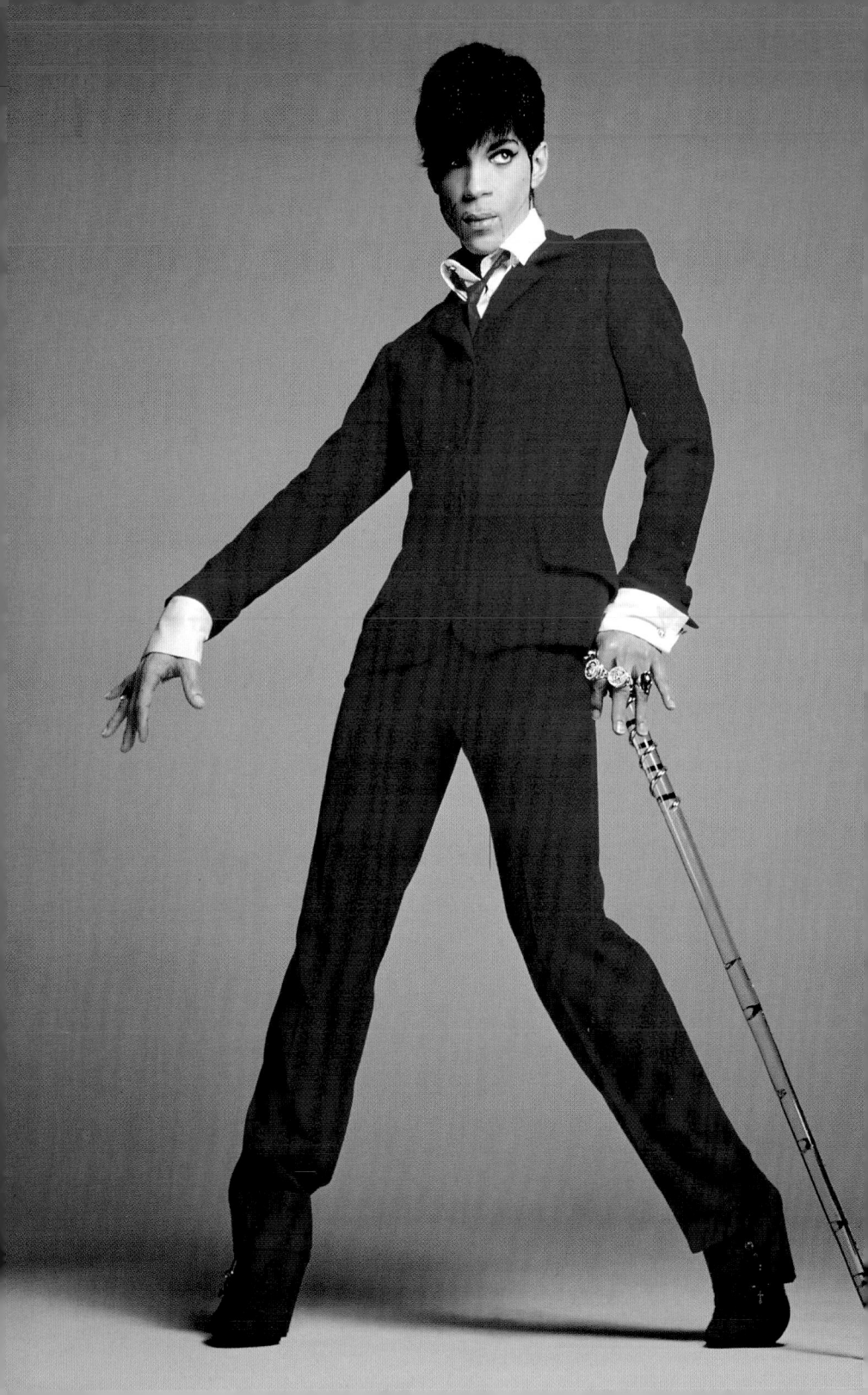

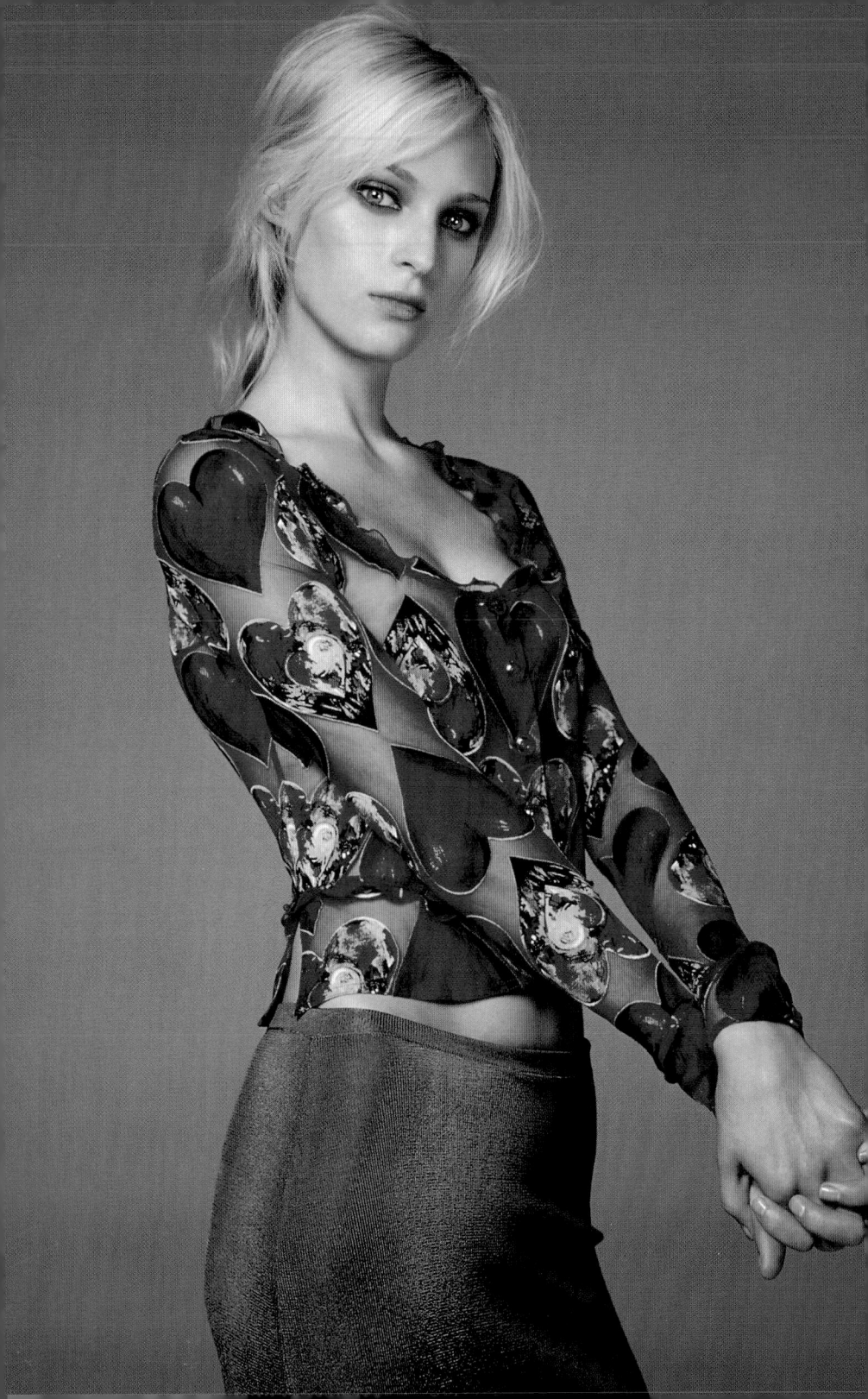

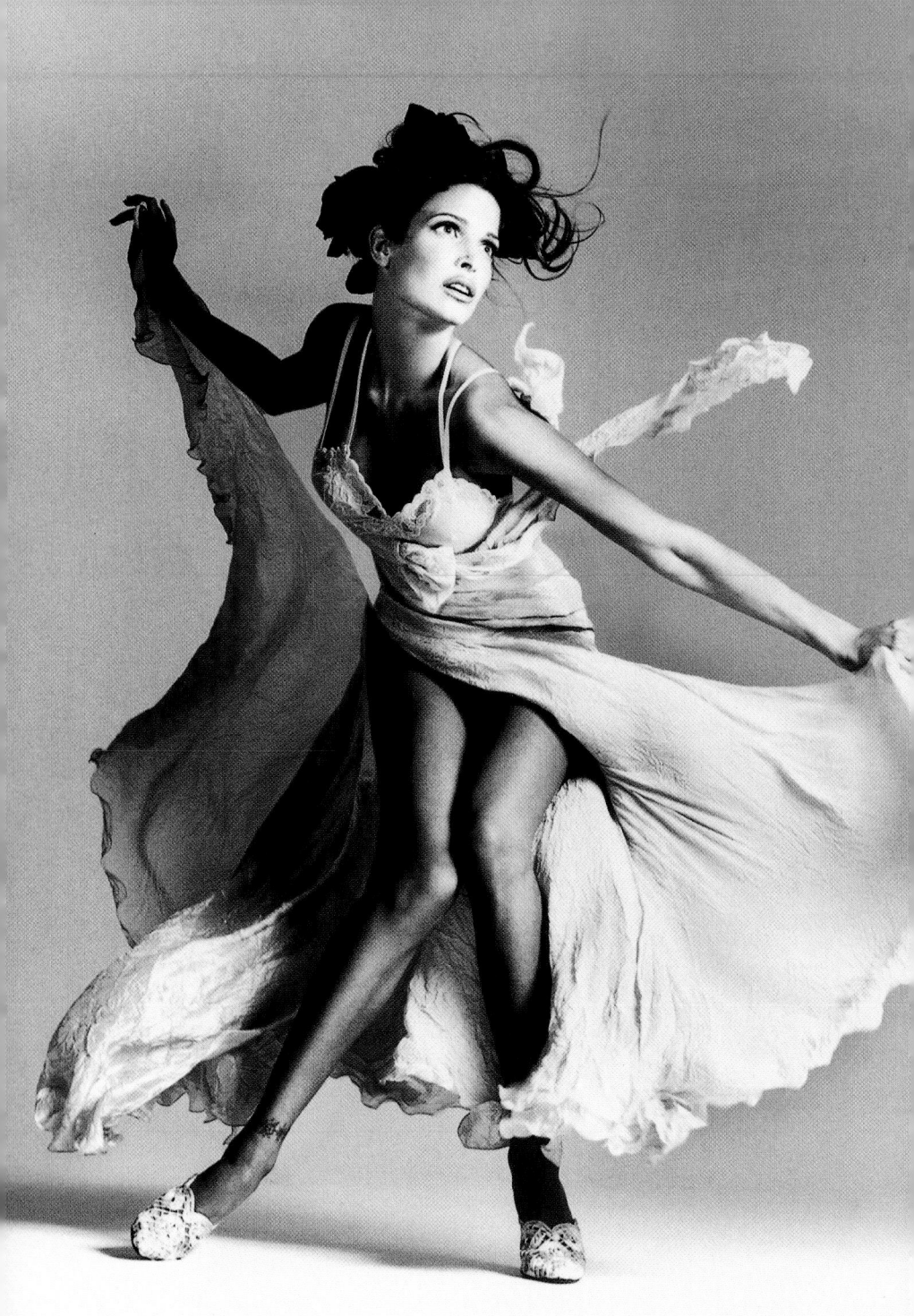

Chronology

1946	Born on 2 December in Reggio Calabria, Italy.
1972	Starts working as a designer in Milan, after an apprenticeship in his mother's dressmaking establishment.
1975	Shows his first leather collection for Complice.
1978	Shows his first collection for women under his own name.
1982	Designs costumes for a production of Richard Strauss's ballet *Josephlegende* at La Scala, Italy.
1983	Designs costumes for a production of Gustav Mahler's ballet *Lieb und Leid*.
1984	Designs costumes for productions of Donizetti's *Don Pasquale* at La Scala and the ballet *Dyonisos*, directed by Maurice Béjart.
1985	Versace gives a conference at the Gianni Versace Exhibition at the Victoria and Albert Museum, London.
1986	The Italian President makes Versace a 'Commandatore' of the Italian Republic. Retrospective exhibition of the last ten years of design takes place at the National Field Museum, Chicago. Presented with the 'Grande Médaille de Vermeil de la Ville de Paris' by Jacques Chirac, on the occasion of the exhibition 'Dialogues de mode', which examines the close working relationship between the designer and leading fashion photographers (Avedon, Newton, Penn, etc.). Designs costumes for the ballet *La Métamorphose des dieux* by André Malraux (choreography by Maurice Béjart).
1987	Designs costumes for productions of *Salome* by Richard Strauss, with stage design by Bob Wilson, and Béjart's *Leda et le Cygne* and *Souvenir de Leningrad*. Receives the 'Maschera D'Argento' (Golden Mask) for his contribution to theatre. Publication of the book *Versace Teatro* by Franco Maria Ricci, one of a series of titles dedicated to Versace's work in the world of theatre and fashion.
1988	Designs costumes for Zizi Jeanmaire's most recent recital at the Bouffes du Nord theatre, Paris, and for his ballet *Java Forever* at the Opéra Comique. Elected the world's most creative and innovative designer for men by the 'Cutty Sark' jury.

*Arabesque. Versace's designs seduce the photographer in search
of a beautiful image. Photo: Richard Avedon. Autumn/Winter Collection
1993–94. © Archives Gianni Versace.*

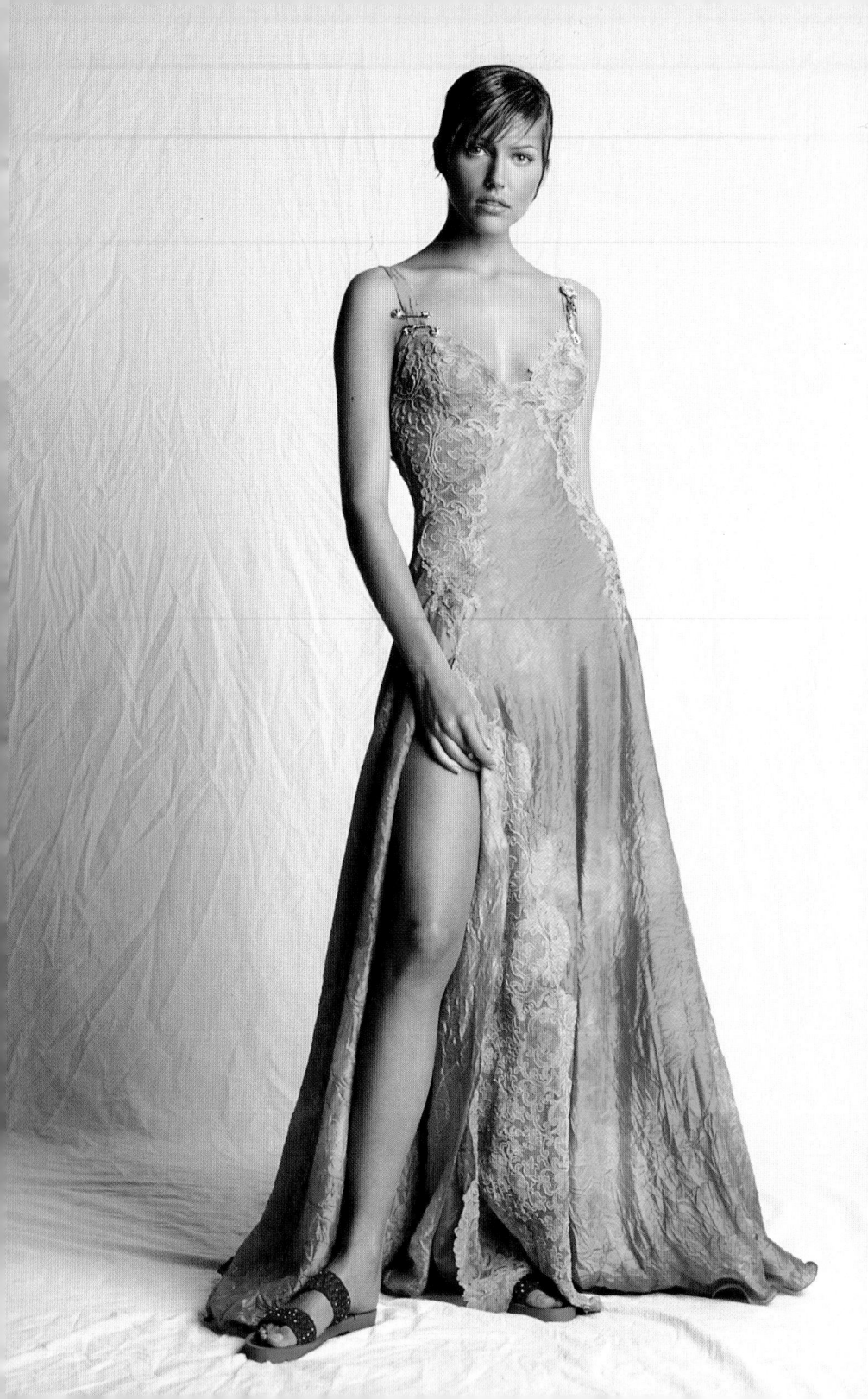

1989	Opens the 'Atelier Versace', a studio for the creation of Versace haute couture designs.
	Designs costumes for a production of *Doktor Faust* directed by Bob Wilson, and for Béjart's productions of *Chaka Zulu* and *Élegie pour Elle*.
	Presents his new young fashion line 'Versus', based on more informal themes.
1990	The San Francisco Opera opens its season with a production of Richard Strauss's *Capriccio* with costumes by Versace.
1991	Exhibition 'Versace Teatro' at the Royal College of Art, London.
	Designs costumes for William Forsythe's ballets in Frankfurt.
	Receives the 'Occhio d'Oro' award for the fourth time.
	Publishes *Vanitas, lo stile dei sensi*, the first in a new series of annual volumes.
1992	The 'Versace: Signatures' retrospective exhibition opens at the Fashion Institute of Technology (F.I.T.), New York.
	Designs stage costumes for the world tour of Elton John, one of Versace's greatest admirers.
1993	Awarded a fashion Oscar by the Council of Fashion Designers of America.
	Designs costumes for Béjart's ballet *Sissi l'impératrice anarchiste*.
	Launches 'Home Signature', a new line of accessories for the home.
1994	The 'Versace: Signatures' retrospective exhibition opens at the Kunstgewerbemuseum, Berlin.
1995	Versace sponsors an exhibition of the work of the photographer Richard Avedon in Milan. Designs costumes for a new production by the American Ballet Theatre, *How Near Heaven*, choreographed by Twyla Tharp.
1996	Opening of 'WeberVersaceViaggiVogue', the first exhibition of photographer Bruce Weber's work in Italy, sponsored by Versace.
1997	Designs costumes for a new ballet choreographed by Béjart, *Le Presbytère n'a rien perdu de son charme ni le jardin de son éclat*, with music by Mozart and the pop group Queen.

Versace's creations present the photographer with a wonderful opportunity to reconcile movement and repose.
Photo: Doug Ordway, Spring/Summer Collection 1994.
© Archives Gianni Versace.

Versace

The family. At the very centre of Versace's work, the family provides mutual support and a sense of solidarity. It was, after all, his mother who introduced him to the joys of fashion design. Photo: Alfa Castaldi, 1976. © Archives Gianni Versace.

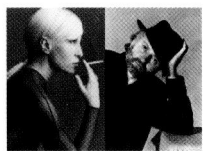

The relationship between Gianni Versace and his sister Donatella is one of collaboration. She is alternately *confidante*, muse and designer in her own right. Left, photo: Steven Meisel. Right, photo: Irving Penn. © Archives Gianni Versace.

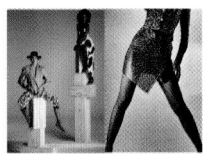

Visual impact, female impact. Although a photo taken in 1983 by Richard Avedon sets women on a pedestal, Versace prefers a woman who relies for her power solely on herself by juxtaposing bold forms: lively animal prints, masculine trousers and jacket. A Bruce Weber shot for the Autumn/Winter Collection 1989–90 shows that **a Versace skirt** might well be a unisex garment of classic simplicity. © Archives Gianni Versace.

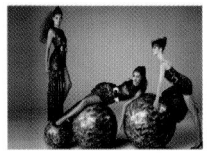

The metallic dress. In collaboration with the photographer Richard Avedon, Versace has created a new compositional style for portraying fashion, the successor to the traditional group photographs presenting the star items of a collection. The sensual and fluid fabric used in these metallic dresses has become one of Versace's favourites since the first dress of this kind appeared in the Autumn/Winter Collection 1982–83. © Archives Gianni Versace.

Aesthetic life. Untiringly up-to-date, Versace also attributes great value to the unlimited pleasures of a rich and varied aesthetic life, full of references to classicism, the Renaissance and the Baroque. **His interest in the past** and in the history of art in general is visible everywhere. Left, photo: Bruce Weber. Right, photo by Helmut Newton, taken from Versace's home on the shores of Lake Como. © Archives Gianni Versace.

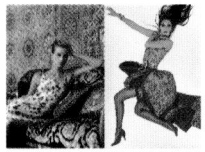

A taste for pattern. Two floral pattern dresses designed several years apart illustrate the modernity of the Versace style. Left, photo: Steven Meisel, Spring/Summer Collection 1995. Right, photo: Richard Avedon, Spring/Summer Collection 1988. © Archives Gianni Versace.

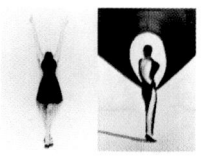

Shape. Herb Ritts's photographs beautifully convey Versace's favourite game of alternately veiling and unveiling the body. Fascinated by the thirties and an admirer of Vionnet and Grès, the designer is adept at exploiting the contrast between artfully revealed skin and garment. The skill of the photographer and the alternating play of open and closed shapes much favoured by the designer give rise to these haunting images. Autumn/Winter Collection 1991–92. © Archives Gianni Versace.

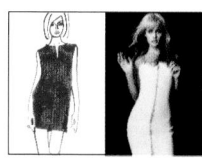

Functional elegance. Encouraged by the modern conviction that beauty is born of simple expressions of function, Versace creates dresses that are elegant and easy to wear. The zip fastener is always in the middle and to the front, but it creates the same effect as a stripe or a zip in an abstract painting by Barnett Newman. Drawing: Mats Gustafson. © Artist A+C Anthology. Photo: Steven Meisel. © Artist A+C Anthology.

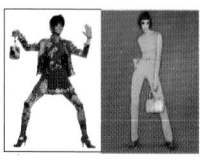

Total look. Although Versace often envisages outfits as separates, he displays an absolute mastery of style and the matching of colours. Accessories play an important role in his world. Left, photo: Irving Penn, Spring/Summer Collection 1991. © Archives Gianni Versace. Right, 'Rage de Vert'. © *Vogue*, February 1996, Jean-Baptiste Mondino.

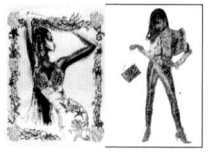

Sexy Baroque. In the early 1990s, Versace created Baroque beauties with sexy silhouettes adorned with bold prints, accessories and costume jewelry. Eclectic references to Byzantine mosaics, tattoos and Baroque interiors. Sketch: Thierry Perez. Photo: Irving Penn. Spring/Summer Collection 1992. © Archives Gianni Versace.

Ornaments. Photo: Irving Penn, Spring/Summer Collection 1992. © Archives Gianni Versace. **Versace's bustiers** seem to be inspired by modern-day bathing costumes as much as by 18th-century courtly dress. The ornamental straps, visible in Steven Meisel's photo for the Spring/Summer Collection 1995, can be seen as the functional straps of a bathing costume or as Rococo-style ornament. © Archives Gianni Versace.

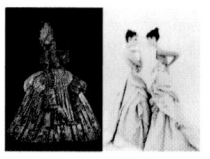

A taste for spectacle. Left, full-skirted gown designed as a costume for *Souvenir de Leningrad*, a Maurice Béjart ballet staged in 1987. © Archives Gianni Versace. Right, photo: Steven Meisel. Spring/Summer Collection 1994. © Archives Gianni Versace.

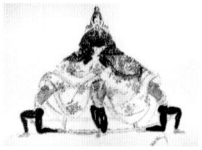

Theatre meets fashion. Versace allows his imagination free rein. He shows no hesitation in adorning a society woman, supported by splendid male caryatids, in a dress with an outrageously wide crinoline. Floral patterns, draped cashmere and inspiration from the 17th century all went into this costume created for *Souvenir de Leningrad*. Drawing: Weber. © Archives Gianni Versace.

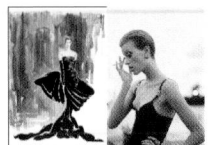

Concept and theatre. The impact of form, both in images and the theatre, acts as a dynamic impetus on Versace. His costume designs for operas, ballets and the theatre verge at times on fashion. His taste for spirited performance allows him to take his ideas on fashion to their logical conclusion. However practical and up-to-date he may be, Versace will always remain and idealist. Photo Steven Meisel. © Archives Gianni Versace.

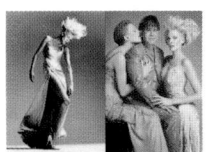

Glamour. In the mid-1990s, Versace used the brilliance and glamour of new materials for his designs. Elton John is one of his faithful admirers. Versace created a number of his stage outfits as well as the sets for his 1992 World Tour. Photos: Richard Avedon. Spring/Summer Collection 1995 and Spring/Summer Collection 1996. © Archives Gianni Versace.

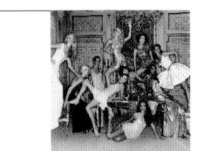

Sensuality of fabric. Thanks to the use of sensual fabrics, the Autumn/Winter Collection 1994–95 hugged the shape of the body. Presented by the top models of the time, the collection was photographed by Michel Comte in Versace's prestigious fashion house. © Archives Gianni Versace.

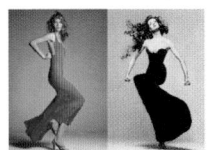

Sensuality of form. Captured in motion by the camera, the evening dresses of the mid-1990s are evocative of modern dance. The supple and fluid forms, which often gain from being cut entirely on the bias, cling to the body, transmitting its powers of seduction with no need for superfluous ornament. The purity of line gives the designs their contemporary look. Photos: Richard Avedon. © Archives Gianni Versace.

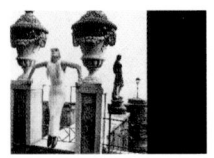

Donatella Versace, the muse, is also co-designer of the Versus label. Photographed by Helmut Newton on the shores of Lake Como, Donatella, the icon of Italian fashion, wears a dress from the Prêt-à-Porter Collection Spring/Summer 1995. The image is on the borderline between tradition and modernism. © Archives Gianni Versace.

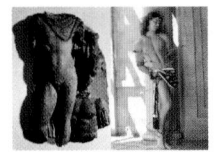

Art and fashion. Bruce Weber's artistic images for Versace are evidence of the latter's undying faith in art and beauty. He plays again with the paradigms of earlier masterpieces, moved by a passionate conviction that beauty is still to be discovered, created through fashion. Life imitates art, not to achieve artifice but to attain beauty. © Archives Gianni Versace.

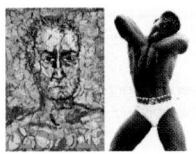

Versace's sensibility tends towards a continuity of classicism. His references to Neoclassicism are frequent, as in this photograph by Bruce Weber, but he also derives his inspiration from the work of contemporary artists such as Julian Schnabel. Left, a work by Julian Schnabel executed for Gianni Versace. Right, photo: Bruce Weber. © Archives Gianni Versace.

Pattern and colour. Variety of pattern constitutes an essential part of Versace's style. He freely draws inspiration from nature, creating an animal imagery based entirely on hyperbole. Photo: Richard Avedon, Spring/Summer Collection 1996. © Archives Gianni Versace. **Sumptuous scarves** © Archives Gianni Versace

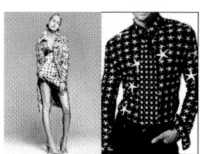

Masculine/feminine. Versace exalts female sensuality as much as male, using fabrics in accordance with the image he wishes to convey of woman, sensual and powerful, and man, strong and romantic. Left, photo: Richard Avedon, Spring/Summer Collection 1996. Right, photo: Bruce Weber, Spring/Summer Collection 1996. © Archives Gianni Versace.

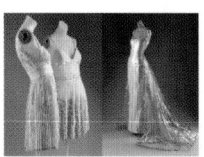

Haute Couture. The Atelier Collection (Summer 1989) encapsulates Versace's vision of haute couture in which he adds to his other *tours de force* by his handling of materials. Short dresses inspired by lingerie also resort to patchwork techniques, to pleating or lace. Likewise, a **ballgown** from the Autumn/Winter Collection 1991–92 in polyvinylchloride (PVC) forced fashion designers to take up the challenge of plastic. 1995, © Metropolitan Museum of Art.

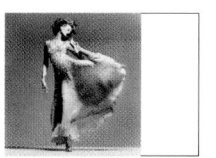

Elegance and vitality. Constantly aware of the importance of freedom and movement, Versace designs dresses which not only allow mobility but actually seem to create it. Thus, even an evening dress designed in 1995 becomes animated, expressing passion and exuberance, in a photograph by Richard Avedon. As far as the designer is concerned, movement and lack of restriction must lie at the foundation of the garment. © Archives Gianni Versace.

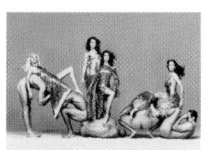

The meaning of the image. In a composition evoking the sculpture of classical architecture, but with the aid of figure-hugging dresses radiating sensuality, Versace conjures up with his models an image of Mount Olympus. Photo: Richard Avedon. © Archives Gianni Versace.

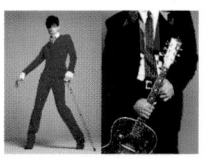

Fashion and music. Versace has a great appreciation of the staging of musical performances, whether opera or rock, by Prince, Elton John or Madonna. No top designer has invested as much as he has in rock or pop music. Left, photo: Richard Avedon, Autumn/Winter Collection 1993–94. Right, photo: Bruce Weber. © Archives Gianni Versace.

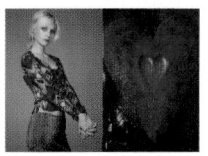

Contemporary art. Jim Dine is one of the artists with whom Versace maintains a fruitful friendship. He draws inspiration from his work and it constitutes an integral part of his daily life since Dine, like Julian Schnabel, has produced works for Versace's New York home. Photo: Richard Avedon, Spring/Summer Collection 1997. © Archives Gianni Versace. Detail of a painting by Jim Dine. © Archives Gianni Versace.

Captions translated from the French by Ruth Taylor

The publishers wish to thank the Maison Versace for its assistance in producing this book and in particular Gianni and Donatella Versace, Patricia Cucco and Sylvia Rossi. Thanks are due also to Elton John and The Artist Formerly Known as Prince.
Thanks to Richard Avedon, Bruce Weber, Irving Penn, Herb Ritts, Helmut Newton, Steven Meisel, Jean-Baptiste Mondino, Mats Gustafson, Doug Ordway, Massimo Listri, Michel Comte, Alfa Castaldi, Thierry Perez.

In addition to Stephanie Seymour, Linda Evangelista, Helena Christensen, Claudia Schiffer, Amber Valletta, Cindy Crawford, Christy Turlington, Naomi Campbell, Shalom, Kirsten Mc Nemany, Nadège, Karen Mulder and Nadja Auermann.

Lastly, this book could not have been produced without the valuable assistance of Rosanna Sguerra (Art & Commerce), Jeff Sowards (Michel Comte Inc.), Chris (Yannick Morisot), as well as Sabine Killinger (Elite), Jean-Marc (Marilyn Agency), Cathy Queen (Ford NY) and Deanna Cross (Metropolitan).

Our thanks to them all.